THE PITTSBURGH PIRATES

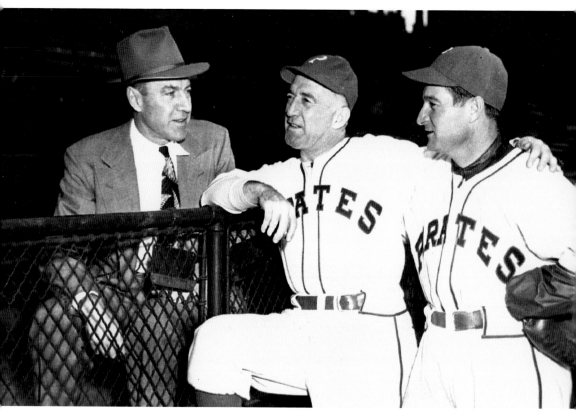

Frankie Frisch enjoys a light moment during a game. Light moments were few and far between for the combative Pirates manager. Once he let a fan who was abusing him from the stands make some decisions during a game. After the Pirates lost 7-4, Frisch asked the fan where he worked. He then told the fan that he would be there later that week to tell him how to do his job. (Courtesy of the Pittsburgh Pirates.)

On the front cover: Please see page 84. (Courtesy of the Pittsburgh Pirates.)

On the back cover: Please see page 88. (Courtesy of the Pittsburgh Pirates.)

Cover background: Please see page 102. (Courtesy of the Pittsburgh Pirates.)

THE PITTSBURGH PIRATES

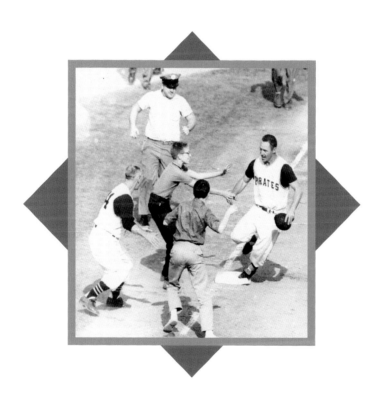

David Finoli

ARCADIA
PUBLISHING

Published by Arcadia Publishing
Charleston, South Carolina

Printed in the United States of America

Library of Congress Catalog Card Number: 2006930222

For all general information contact Arcadia Publishing at:
Telephone 843-853-2070
Fax 843-853-0044
E-mail sales@arcadiapublishing.com
For customer service and orders:
Toll-Free 1-888-313-2665

Visit us on the Internet at www.arcadiapublishing.com

*To the people that make my life so perfect, my wife Viv
and my three children, Tony, Matt, and Cara.*

*Also to the memory of my Uncle Ed who helped
foster my love of baseball.*

CONTENTS

ACKNOWLEDGMENTS

You cannot do an undertaking of such projects without the incredible help and support from your family and friends. I thank not only my wife Vivian and kids Matt, Cara, and Tony, whom I am grateful for every day, but also my mother Eleanor, father Domenic, my sister Mary, her husband Matt, my brother Jamie, his wife Cindy, my wonderful nieces Brianna and Marissa, as well as the rest of my family. Last but certainly not least my in-laws Vivian and Salvatore Pansino.

A huge thanks also goes out to Bill Ranier, one of the foremost Pirates historians, Chris Fletcher and Tom Aikens for not only their assistance on this project when needed, but their friendship over the last quarter century and beyond.

This book would also not have been possible without the help of Jim Trdinich and Dan Hart of the Pittsburgh Pirates for their help and contributions of the wonderful photographs found in this book. Finally a huge thank-you to Tiffany Howe and the fine people at Arcadia Publishing who made this project not only a reality, but a very positive experience.

All the wonderful photographs for this book are courtesy of the Pittsburgh Pirates, except for the following: page 11, photograph of the fans (image ggbain 10902); page 17, George Gibson (image ggbain 03273); page 18, fans on the pole (image cph 3c03768); page 23, Honus Wagner (image cph 3b19119); page 24, Honus Wagner, Mike Donlin, Fred Clarke, Marty O'Toole (image ggbain 10375); page 27, Ed Konetchy (image cph 3c33662); and page 32, Johnny Morrison (image ggbain 31124) all are from the George Grantham Bain Collection from the Library of Congress. Also, the image on page 127 of PNC Park is courtesy of Bill Ranier.

INTRODUCTION

It has not exactly been the best of times for the Pittsburgh Pirates since 1992. Fourteen consecutive losing seasons have thrown this franchise into a tailspin that has been unparalleled in its 122-year history; but what a 122-year history it has been.

The Pirates may not have begun the 21st century with much of a bang, but make no mistake, in the 20th century they were among the most successful teams in the long and illustrious history of the national pastime.

Pittsburgh entered the 1900s much like they entered 2000, not exactly a pennant contender. That all changed for the Bucs, ironically, at the misfortune of another franchise, the Louisville Colonels. Following the 1899 campaign, the Colonels folded. Their owner Barney Dreyfuss was allowed to buy into the Pirates, which turned out to be very fortuitous for the Bucs and their loyal fans. He brought with him a nucleus that included such superstars as Fred Clarke, Tommy Leach, Deacon Phillippe, Claude Richey, Rube Waddell, Chief Zimmer, and a bowlegged shortstop from Carnegie who would become the greatest player, unparalleled, in franchise history, Honus Wagner.

It was these building blocks around which Dreyfuss would construct his powerhouse of the early 1900s. This collection would go on to form Pittsburgh's greatest dynasty, winning four National League pennants and a world championship in the 20th century's initial decade.

As the second decade of the 20th century began, the Pirates began to age quickly and questionable personnel decisions eroded this once-mighty club. Eventually the franchise would rise from the ashes in the 1920s with the addition of such luminaries as Pie Traynor, Kiki Cuyler, and the Waner Brothers. They went to two World Series in three years, capturing the 1925 fall classic in dramatic fashion, becoming the first team ever to fight back from a three-games-to-one deficit.

The Pirates would not experience the sweet taste of champagne again for 35 years, but even during the darkest times, there was always a shining beacon. Ralph Kiner won seven consecutive home run titles while almost single-handedly helping Pittsburgh rank at the top of the league in attendance, despite the fact that those Bucco teams were among the worst in their history. Dale Long performed his Ruthian feat in 1956, hitting home runs in eight consecutive games, a mark that still has yet to be eclipsed 50 years later. There was Gus Suhr, Bob Elliott, Elbie Fletcher, Dick Bartell, and Al Lopez to name just a few, as well as Pittsburgh's other hall of fame No. 21, shortstop Arky Vaughan. Vaughan ironically also died too young, and as a hero just like the Bucs more famous 21, when he drowned in 1952 trying to save his friend after his boat capsized.

Losing became an epidemic in the late 1940s through the mid-1950s as the Pirates fielded several horrific teams. Help was on the way though. Legendary general manager Branch Rickey and then the young wunderkind Joe L. Brown were stockpiling impressive young talent, the building blocks of a new championship era. They got a second baseman out of West Virginia in Bill Mazeroski, pitchers Bob Friend, and Vernon Law, a shortstop who was more well known as the national collegiate player of the year in basketball while at Duke by the name of Dick Groat, and the most important piece, a budding superstar from Puerto Rico, who the club stole from

the Dodgers and would not only become baseball's first true Latin superstar, but one of the most distinguished heroes the sports world ever produced, Roberto Clemente.

Brown, through very adept trades, would add Bill Virdon, Harvey Haddix, the architect of the greatest game ever pitched in 1959, Don Hoak, Smoky Burgess, and Vinegar Bend Mizell, who became a U.S. congressman from North Carolina in 1966, to the mix to put the Pirates over the top. These players helped set the baseball world on its ears in 1960, when it first shockingly won the National League pennant before toppling the powerhouse New York Yankees in seven memorable games, the last of which is considered one of the true gems in major-league history. That day, the two clubs battled tooth and nail to a 9-9 tie as the Bucs came to the plate in the bottom of the ninth inning. It was then, at 3:37 p.m. to be exact, that Bill Mazeroski became a legend when he parked a Ralph Terry pitch over the left field wall to give Pittsburgh a dramatic 10-9 win, the only time a Game 7 in the fall classic has ever ended on a home run.

The leader of that memorable squad was a former second baseman for the Pirates by the name of Danny Murtaugh who took over the reigns of the club late in 1957. It was Murtaugh who retired four times, yet would always be called back by Brown to turn around a sinking ship. After being so close on a couple of occasions in the 1960s, thinking he was only a player away, Brown traded for that one veteran who he thought was the missing piece bringing in the likes of Jim Bunning and Maury Wills. Unfortunately that was not the case, so Brown decided not only to tap into his remarkable wealth of minor-league talent, he also brought back Murtaugh to see if lightning could strike twice; it did and more. With everything in place, the Pirates embarked on their most successful decade since the early 1900s, capturing five eastern division championships in six years and the 1971 world championship.

As successful as the 1970s were, they were also somewhat tragic. In 1976, pitcher Bob Moose, the Export native who tossed a no-hitter against the Mets in 1969, died in a car accident on his 29th birthday. Then of course there was the death of the team's patriarch and its most heroic figure on New Years Eve 1972. That was the day when Roberto Clemente's plane went down in the Atlantic Ocean while he was on his way to deliver relief supplies to earthquake-ravaged Nicaragua, sadly ending his magnificent life at the age of 37. The city has never forgotten its fallen hero.

The team eventually recovered on the field, winning its fifth World Series championship as the decade came to end when Willie Stargell and the Fam-A-Lee once again beat the Baltimore Orioles in seven games. It would be the last world championship the franchise has won to date.

Over the last 27 years the team has had only seven winning seasons, capturing three eastern division titles between 1990 and 1992, but hopefully better times are ahead. As we settle into the 21st century, the Bucs have a good young core that gives hope for a return to their former championship form. Could Zach Duke, Ian Snell, Jason Bay, Freddy Sanchez, and Jose Castillo be the second coming of Clemente, Mazeroski, Groat, Law, and Friend? Perhaps. One thing is for sure though, in the 20th century, there were few franchises that gave their fans as many thrills and special moments as the Pittsburgh Pirates have given the loyal baseball fans of the Steel City. It is a proud tradition that the pages of this book will remember and celebrate.

DYNASTY

1900 – 1909

Top five moments during the decade:

1. Forbes Field proved to be a good-luck charm as the Pirates overcame Ty Cobb and Detroit to win the 1909 World Series in the facility's first year of existence. Babe Adams won three games in the series.
2. Pittsburgh played the Boston Americans in the first World Series game ever on October 1, 1903, as the Bucs defeated Boston 7-3.
3. Pittsburgh finished 103-36 to capture the 1902 National League crown. Jack Chesbro won a team modern-day record 28 games during the campaign.
4. Barney Dreyfuss bought the Pirates after his Louisville Colonels folded following the 1899 campaign.
5. Honus Wagner hit .339 in 1909 to win his fourth consecutive batting crown. It would be the seventh batting title Wagner would earn in the decade.

Team of the decade:

Kitty Bransfield (first base)
Claude Richey (second base)
Honus Wagner (shortstop)
Tommy Leach (third base)
Fred Clarke (left field)
Ginger Beaumont (center field)
Jimmy Sebring (right field)
George Gibson (catcher)
Jesse Tannehill (left-hander)
Sam Leever (right-hander)
Charles "Deacon" Phillippe (relief pitcher)

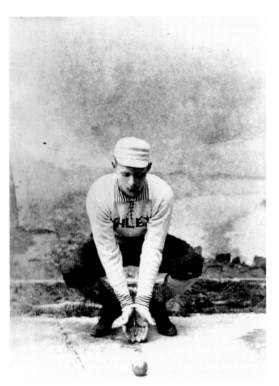

Lou Bierbauer helped inspire the club's current nickname "the Pirates" when the team signed the second baseman from Philadelphia in 1891. Bierbauer jumped to the newly formed Players League in 1890, and when the circuit folded a year later, Pittsburgh took advantage of a clerical error the Athletics made, "pirating" him from their protected list.

Piloting the Bucs to their best finish in the 19th century was manager Al Buckenberger. Pittsburgh finished the 1893 campaign with an 81-43 mark good enough for second in the National League. A year later, Buckenberger was one of three men suspended by the National League for conspiring with officials from the American Association. Buckenberger would be reinstated in 1895 and went on to manage St. Louis and Boston.

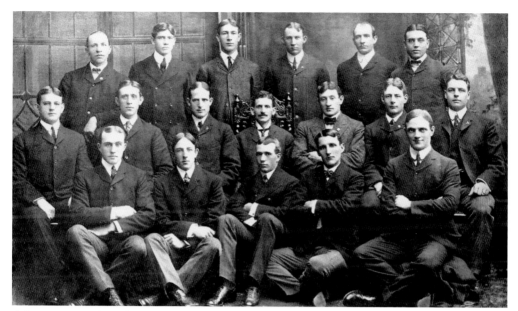

After winning their third consecutive National League pennant in 1903, the Pirates went on to play in the first World Series ever. Facing the Boston Americans, champions of the fledgling American League, Pittsburgh could not overcome several key injuries and fell to the upstart Americans five games to three. Pictured in the middle row, third, fourth, and fifth from the left are Fred Clarke, Barney Dreyfuss, and Honus Wagner.

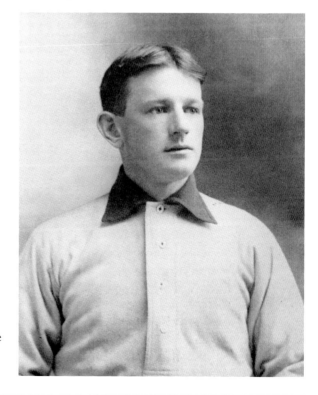

A spitballer extraordinaire, pitcher Jack Chesbro set the all-time Pirates record for wins in 1902 when he finished at 28-6. Chesbro moved to the American League's New York Highlanders (Yankees) in 1903 and won a major-league record 41 games two years later in 1904. Elected to the hall of fame in 1948, neither his Pirate nor major-league records have been eclipsed in the last 100-plus years.

Coming over from the Louisville Colonels with owner Barney Dreyfuss, Charles "Deacon" Phillippe became one of the club's best pitchers during the first decade of the 20th century. Phillippe was a 20-game winner five times and won 154 games over that time period. He was at his best at the first World Series in 1903, winning all three games that the Bucs captured during the fall classic.

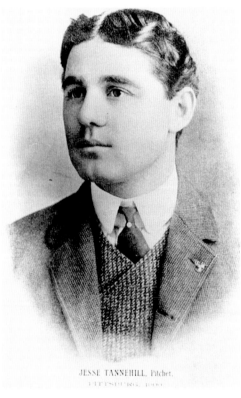

JESSE TANNEHILL, Pitcher.
PITTSBURG, 1900

Pitcher Jesse Tannehill not only has the best winning percentage in Pittsburgh history with a .667 mark, he was also the first major Pirate to defect to the American League. Tannehill was coming off a 20-6 campaign when he and several of his teammates were offered $1,000 to jump to the new circuit. Soon after admitting to Dreyfuss while under anesthesia about the offer, he was released and joined the New York Highlanders.

DYNASTY

Nicknamed "Ginger" because of his bright red hair, Clarence Beaumont started his major-league career with a bang, hitting .352 in his rookie year in 1899. Three years later, the mercurial center fielder would capture his one and only batting title when he hit .357 for the Bucs in 1902.

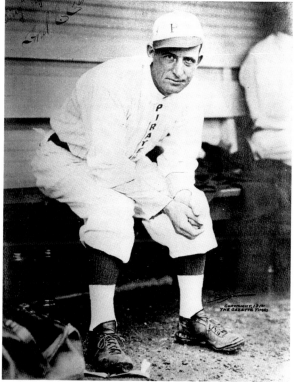

Fred Clarke was one of the few men in baseball history to have qualifications as both a manager and a player to enter the hall of fame. A phenomenal left fielder who hit .312 for his career, Clarke also was the most prolific manager in club history, winning 1,422 games, four National League pennants, and the 1909 World Series. Clarke was given his spot among baseball's elite when he was elected to Cooperstown in 1945.

THE PITTSBURGH PIRATES

When it comes to shortstops in baseball history, the argument as to who is the best begins and ends with Honus Wagner. Usually considered one of the top 10 players of all time, Wagner led the league in hitting eight times while compiling a .327 career batting average.

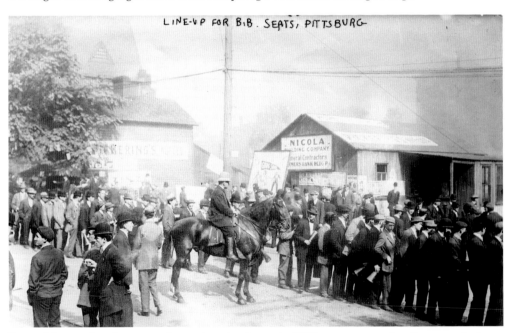

Excited Pirates fans line up to buy tickets in the early 1900s as a mounted policeman sits by to make sure things stay under control. They called Pittsburgh in the first half of the 20th century the Smokey City because of its many steel mills. Notice the thick smoke hanging over the buildings that often made it tough for Pittsburghers to distinguish between day and night.

As a rookie in 1907, pitcher Nick Maddox etched his name in Pirates lore when he tossed the franchise's first no-hitter on September 20, beating the Brooklyn Dodgers 2-1. Maddox was at his best the next season, going 23-8, but was released only two years later in 1910.

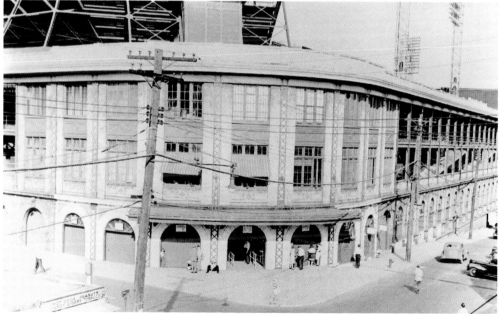

It was an engineering marvel when it first opened on June 30, 1909. The first concrete-and-steel facility in baseball history, Forbes Field was named after the legendary British general in the French and Indian War, John Forbes, who founded Pittsburgh in 1758. Forbes Field would house many memorable sporting events in its 61-year history, including four World Series.

THE PITTSBURGH PIRATES

Howie Camnitz burst onto the Pittsburgh baseball scene in 1907 with a 13-8 mark. Two years later he was among the best hurlers in baseball, leading the world champions with a 25-6 mark good enough for a league-high .806 winning percentage. By the time he was traded to the Phillies in 1913, Camnitz won 20 games three times and became the sixth Bucco hurler to win 100 games.

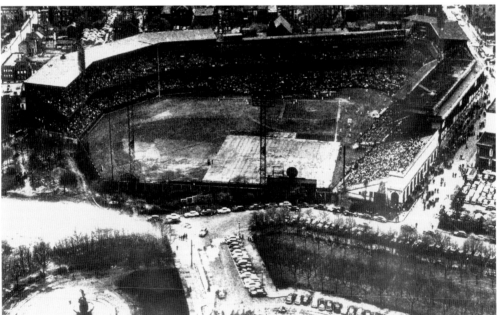

After spending years trying to fight off the floods at Exposition Park, which was built along the river almost exactly where Three Rivers Stadium stood, owner Barney Dreyfuss opened his palace, Forbes Field, in the Oakland section of the city on June 30, 1909. That day, among the ceremonious atmosphere, the Pirates lost to the Chicago Cubs 3-2.

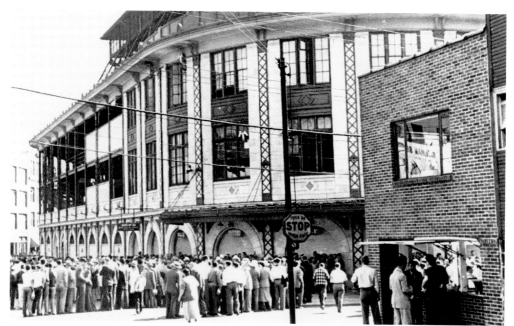

Forbes Field proved to be a good-luck charm for the Pirates as the team won the National League pennant in the facility's first year of existence. Hosting its first fall classic that memorable season, the World Series opened at Forbes Field, where 29,624 excited fans jammed the park to see Babe Adams and the Pirates stop the Detroit Tigers 4-1 in Game 1.

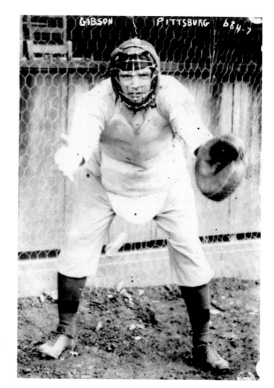

The epitome of a no-hit good glove catcher, George Gibson was a stalwart behind the plate in the early part of the century. Nicknamed "Moon," Gibson was an iron man behind the plate, catching a then-record 140 consecutive games. The London, Ontario, native averaged 144 games a year behind the plate, an unheard of figure at that time.

THE PITTSBURGH PIRATES

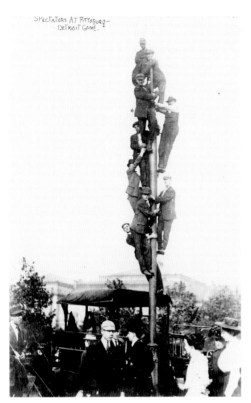

So in demand were tickets to the 1909 World Series that fans would do whatever they had to to catch a glimpse of the action. Here nine fans climb a pole to see the game. Pittsburgh would win two of three contests in Pittsburgh, capturing Games 1 and 5 while losing the second contest 7-2 to the Tigers.

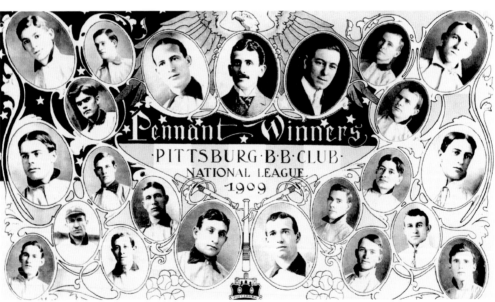

The 1909 Pittsburgh Pirates won the first world championship in franchise history. After completing a tremendous 110-42 campaign in their first year at Forbes Field, Pittsburgh took on Ty Cobb and the Detroit Tigers in the fall classic. Following a back-and-forth struggle in the first six games, Babe Adams tossed a six-hit shutout in an 8-0 seventh and deciding game victory.

WAGNER'S LAST STAND

1910–1919

Top five moments during the decade:

1. On June 19, 1914, Honus Wagner became the first player in the 20th century to amass 3,000 hits.
2. Owen "Chief" Wilson set the all-time record for triples in a season with 36 in 1912. In the past 94 years, the record was never seriously threatened.
3. On July 17, 1914, Babe Adams pitched 21 innings without walking a batter in a 3-1 loss to Brooklyn.
4. Deacon Phillippe won 13 consecutive games in 1910, a team record that has never been bettered.
5. Max Carey swiped 61 bases in 1913. It would be the first of 10 times Carey would lead the National League in stolen bases.

Team of the decade:

John "Dots" Miller (first base)
Jim Viox (second base)
Honus Wagner (shortstop)
Bobby Byrne (third base)
Fred Clarke (left field)
Max Carey (center field)
Owen "Chief" Wilson (right field)
George Gibson (catcher)
Wilbur Cooper (left-hander)
Charles "Babe" Adams (right-hander)
Charles "Deacon" Phillippe (relief pitcher)

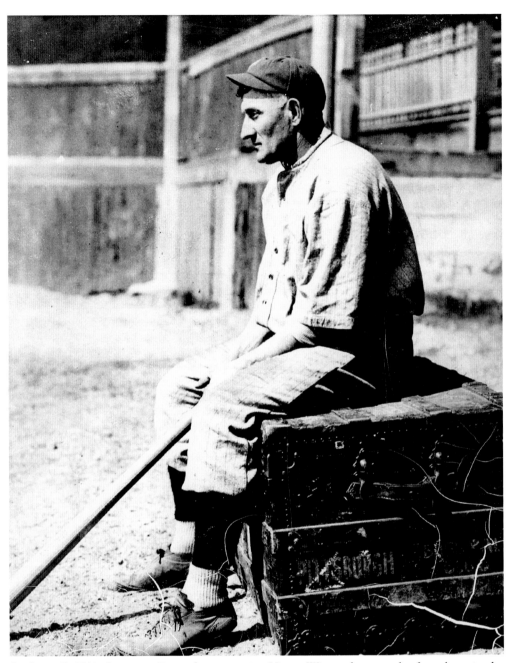

On June 19, 1914, Carnegie, Pennsylvania, native Honus Wagner became the first player in the 20th century and the second overall to eclipse the 3,000-hit plateau when he doubled in the ninth inning against the Phillies at the Baker Bowl. Wagner hit the historic shot in only his 2,332nd game against Erskine Meyer in the ninth inning. Despite the fact he was 40 years old that day, Wagner was at his best, tricking the Phil's Hans Lobert and tagging him out going to third base. Later on he would get Beals Becker with the hidden ball trick.

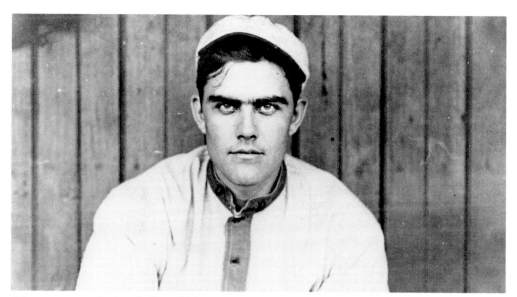

After stunning the baseball world by winning three games in the 1909 World Series, Charles "Babe" Adams set out to prove his legendary performance was no fluke. Adams did that and more, winning 20 games twice for the Bucs in the second decade of the 20th century, including a phenomenal 22-12 record in 1911, a year he also finished third in the circuit in ERA with a 2.33 mark.

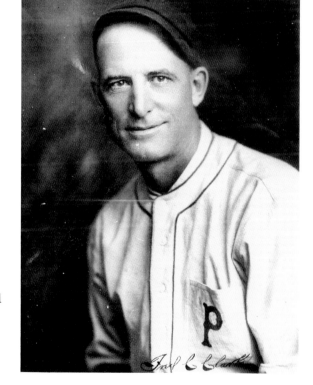

As the second decade of the 20th century began, the career of hall of fame left fielder Fred Clarke was coming to an end. While Clarke garnered 17 at-bats between 1913 and 1915, for all intents and purposes, 1911 was Clarke's last campaign as a player. The Iowa native certainly had quite a swan song, finishing fourth in the National League with a .324 average.

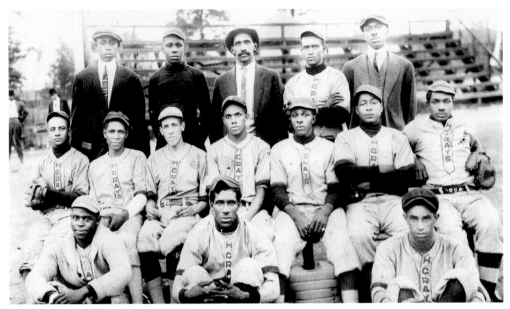

Known originally as the Blue Ribbons and then the Murdock Grays, the Homestead Grays, as they became known in 1912, became one of the most successful franchises in the history of sports. Winning nine straight league titles between 1937 and 1945, the Grays paraded many hall of famers on to the Steel City diamonds, becoming perhaps the most successful Pittsburgh team ever, and a true city treasure.

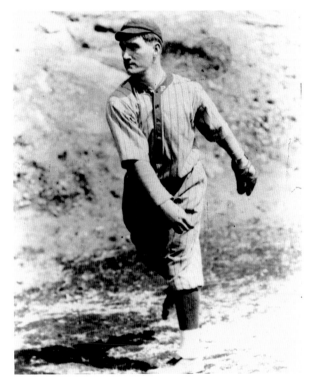

Remembered as one of baseball's first true bonus babies, Marty O'Toole came to the Pittsburgh Pirates via owner Barney Dreyfuss's record $22,500 check. Unfortunately, like so many high-priced phenoms who came after, O'Toole ended up being not quite worth the money. His enduring legacy to the Pirates' record books was the most walks in a season, with 159 in 1912.

WAGNER'S LAST STAND

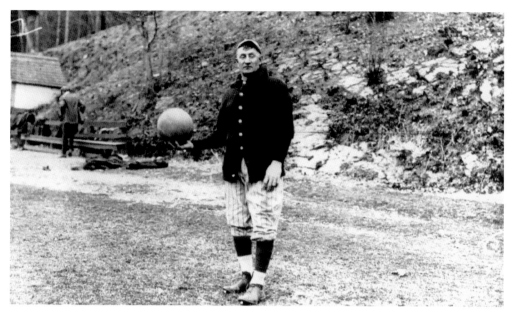

A true baseball icon, teammate Tommy Leach once said of Honus Wagner, "He wasn't just the greatest shortstop ever. He was the greatest everything ever." When he retired following the 1917 campaign, he had amassed such unbelievable numbers as 3,415 hits, 640 doubles, and 722 stolen bases, all of which still rank in the top 10 in baseball history.

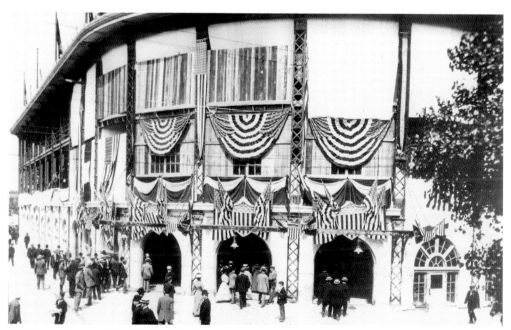

While it is known that Forbes Field was named after the founder of the city, Gen. John Forbes, a lesser-known fact was that the stadium was located on Boquet Street, named after another French and Indian war hero, Gen. Henry Bouquet. The strange but true fact was that the street sign was misspelled.

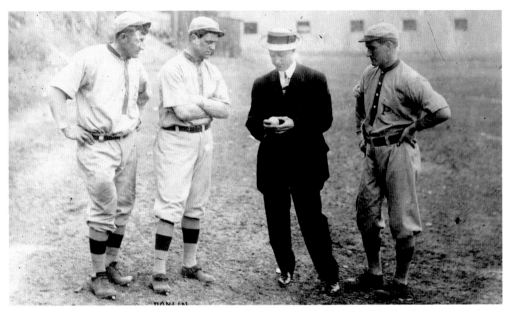

Honus Wagner, Mike Donlin, manager Fred Clarke, and Marty O'Toole (left to right) get together during the 1912 campaign. While the Bucs were 93-58, they finished 10 games behind the eventual National League champion New York Giants. Wagner hit .324 that season, while Donlin, playing in his one and only year in a Pirates uniform, hit .316.

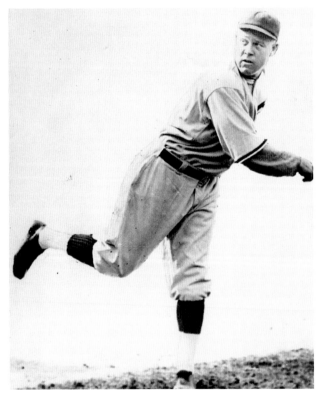

While he was one of the best pitchers in the National League in 1912 when he went 24-9 for the Pirates, Claude Hendrix would eventually put his name up with the likes of Pete Rose before his career was over. Hendrix won 29 games with Chicago of the Federal League. He signed with the Cubs after the circuit folded and was cut when they discovered he allegedly bet against Chicago in a game that he was to pitch.

WAGNER'S LAST STAND

One of the greatest speed merchants the game has ever known was Max Carey. Carey, who spent 16.5 years in the Steel City, swiped 738 bases over his hall of fame career. The .285 career hitter remains today in the top 10 all time in stolen bases where he is ninth, 16 ahead of another Pirates icon, Honus Wagner.

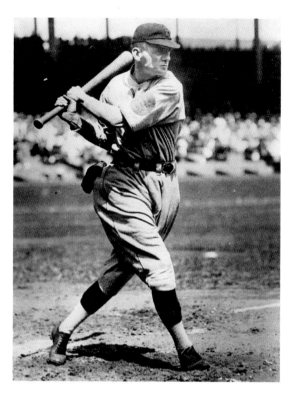

After a fine 10-year career, Babe Adams's career appeared to be over when the Bucs released him with a sore arm during the 1916 campaign. Surprisingly, Adams returned two years later, when the majors were depleted of players in 1918 because of World War I. Adams made a miraculous comeback and by 1919, was an effective starter again, going 17-10 with a 1.98 ERA.

The last legal practitioner of the spitball in major-league history, Burleigh Grimes would turn out to be one of owner Barney Dreyfuss's worst moves. In only his second season, Grimes went 3-16 and was dealt to Brooklyn for George Cutshaw and Casey Stengel. Grimes became a hall of famer with the Dodgers and would eventually return to the Steel City in 1928 where he had a fine 25-14 campaign.

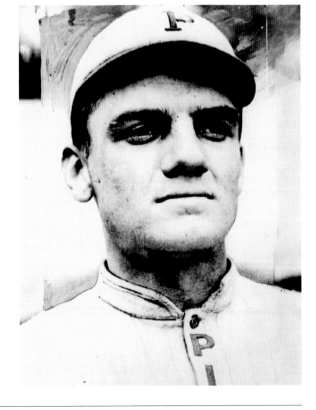

Even though Max Carey was primarily known for his speed, he was also one of the greatest defensive center fielders of his era. Nine times he was the league leader in chances and putouts, and he is the all-time National League leader in career assists for an outfielder with 339.

Fred Clarke turned out to be quite an inventor. Clarke came up with a pulley system that made it easier to pull a tarpaulin over a field when it was raining. He also came up with a way to clip smoked glasses on a baseball hat to help players not lose a ball in the sun, something more commonly known as flip-down sunglasses. He was truly Thomas Edison in cleats.

The Pirates thought they finally had answered their problems at first base when Barney Dreyfuss engineered an eight-player deal with the St. Louis Cardinals to get Ed Konetchy. Konetchy unfortunately was not the answer, hitting only .249 with 51 RBIs in 1914 before jumping to the Federal League's Pittsburgh Rebels in 1915, where he did become a star, hitting .314.

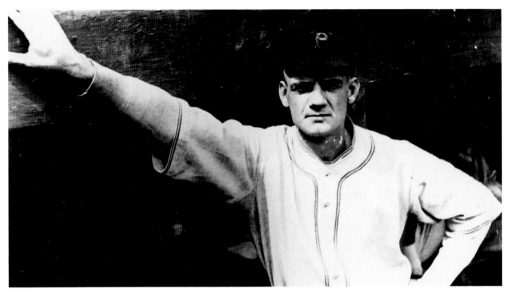

When Max Carey finished his 20-year major-league career in 1929, he went on to become a manager with the Brooklyn Dodgers as well as the president of the All American Girls Professional Baseball League. After years of waiting, 31 years following his retirement to be exact, Carey was given his rightful place in Cooperstown when he was elected to the hall of fame in 1961.

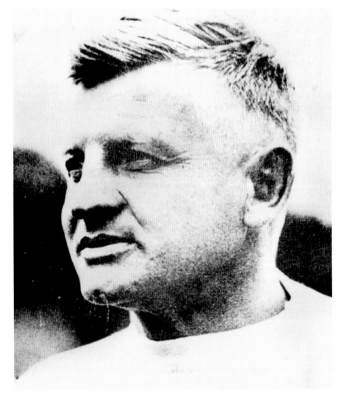

In 1917, Pittsburgh made perhaps their most puzzling managerial move ever when they hired Hugo Bezdek. His qualifications were as a college football coach at Oregon and Arkansas. Bezdek surprised his critics, leading the Bucs to two winning campaigns. Bezdek would become the head football coach both at Penn State and with the Cleveland Rams, making him the only man to manage in the majors and coach in the NFL.

WAGNER'S LAST STAND

CHAMPIONS AGAIN

1920 – 1929

Top five moments during the decade:

1. The Pirates became the first team to come back after being down three games to one to capture the 1925 World Series against the Washington Nationals.
2. Pittsburgh won their sixth National League pennant in 1927, before being swept by the famed 1927 Yankees in the World Series.
3. Paul Waner hit .380, had a team record 237 hits, and drove in 131 to capture the 1927 National League MVP Award.
4. KDKA Radio broadcast the first baseball game ever on August 9, 1921. Pittsburgh beat the Phillies 8-5.
5. Kiki Cuyler got his 10th consecutive hit in a 9-7 win against the Phillies on September 21, 1925.

Team of the decade:

Charlie Grimm (first base)
George Grantham (second base)
Glen Wright (shortstop)
Harold "Pie" Traynor (third base)
Clyde Barnhart (left field)
Max Carey (center field)
Paul Waner (right field)
Earl Smith (catcher)
Wilbur Cooper (left-hander)
Ray Kremer (right-hander)
Johnny Morrison (relief pitcher)

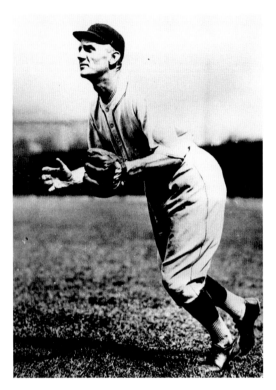

In the 1925 campaign, speedy hall of fame center fielder Max Carey swiped 46 bases to lead the National League. It would be his fourth consecutive stolen base crown and the 10th and final time in his magnificent 20-year career that he would lead the senior circuit in this category.

There were not many pitchers in the annuls of the national pastime that were able to find the plate more often than Charles "Babe" Adams. In 19 major-league seasons, Adams walked only 430 batters in 2,995.1 innings, a total of only 1.29 per nine innings, a figure that is the 18th lowest in baseball history and a mark that only four hall of famers have bettered.

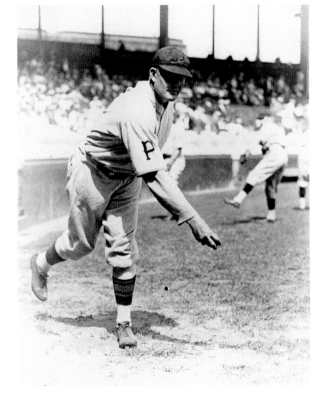

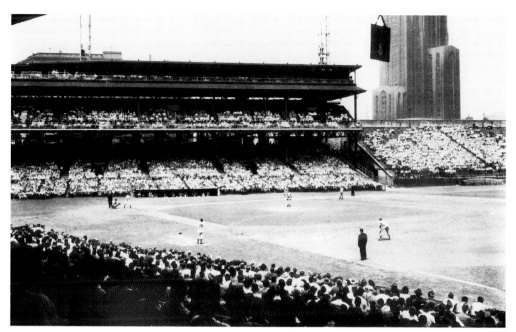

While doubleheaders were very commonplace for most of the 20th century, tripleheaders were not. On October 2, 1920, Forbes Field hosted the last tripleheader in baseball history when the Bucs took on the Cincinnati Reds. After dropping the first two games 13-4 and 7-3, Johnny Morrison shut out the Reds 6-0.

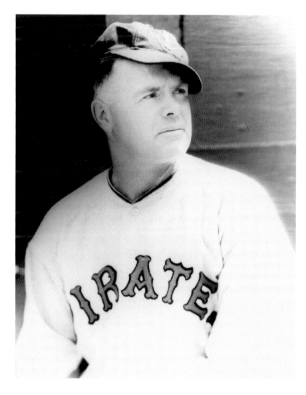

Following a 14-year major-league career, catcher George "Moon" Gibson took over the reins of the team. In two separate stints as the Pirates manager, 1920–1922 and 1932–1934, Gibson led the team to five winning seasons, including a 90-63 second-place finish in 1921. Despite his .549 career winning percentage in Pittsburgh, Gibson was unable to maintain discipline in the clubhouse and was let go both times.

Hall of famers Walter "Rabbit" Maranville (left) and Bill McKechnie stand at the top of the dugout during a game in the early 1920s. Maranville was one of the "Clown Princes of Baseball," who also happened to be a magician defensively at shortstop, while McKechnie was one of the game's great managers who is the only man to lead three different teams to the World Series.

Pitcher Johnny Morrison had one of the most effective curveballs of his era. It helped him have a brilliant season for the Pirates in 1923, going 25-13. Morrison's downfall proved to be his drinking as he was suspended by Pittsburgh on more than one occasion leading to his eventual ouster from the Steel City following the 1927 season.

CHAMPIONS AGAIN

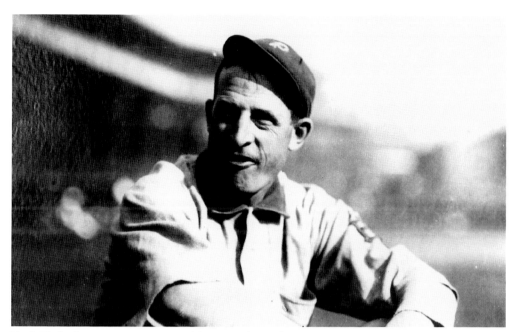

Fred Clarke became a controversial figure in the mid-1920s. He sat on the bench as a managerial consultant, which led to many controversial situations, such as not getting voted a share of the 1925 Series money by the players. Then there was the infamous ABC situation that caused a player mutiny where Clarke's "suggestion" to get Max Carey out of the lineup led to the eventual dismissal of Babe Adams, Carey, Carson Bigbee, and Bill McKechnie.

In a franchise filled with legendary hitters, one is hard pressed to know who the winningest Pirates hurler of all time is. The answer is Wilbur Cooper. This southpaw won 202 games in his 13-year Pittsburgh career, winning 20 games four times for the Bucs including 22 in 1921 when he led the National League in victories.

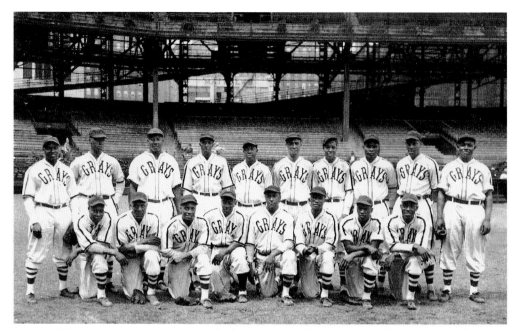

As the 1920s were coming to an end, the Homestead Grays were about to embark on an unprecedented two-decade run as the most successful Pittsburgh franchise of all time. Such hall of fame legends as Josh Gibson, Buck Leonard, Oscar Charleston, and "Smokey" Joe Williams proudly wore the Grays uniform over the franchise's history.

For eight seasons between 1925 and 1932, Homestead Gray "Smokey" Joe Williams dazzled Pittsburgh baseball fans. Over his career, Williams tossed a reported 12 no-hitters and struck out 27 Kansas City Monarchs in 1930. While many consider Satchel Paige the greatest Negro League pitcher of all time, the *Pittsburgh Courier* thought differently, naming Williams the circuit's greatest pitcher in 1950. Williams was elected to the hall of fame in 1999.

CHAMPIONS AGAIN

Hazen "Kiki" Cuyler played the game with a reckless spirit that helped him garner a .321 career average. Perhaps the greatest moment in his 18-year major-league career came in Game 7 of the 1925 World Series. In the bottom of the eighth inning with the Pirates down 7-6 against Washington's Walter Johnson, Cuyler hit a two-out, bases-loaded drive to right-center field clearing the bases and giving the Bucs a 9-7 win and the world championship.

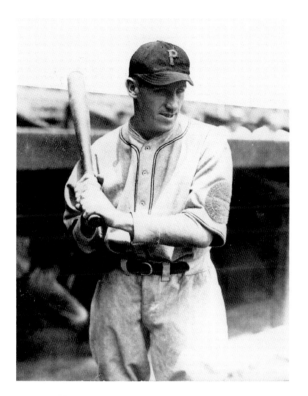

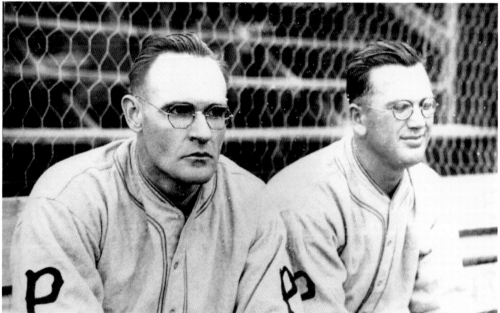

In 1915, Carmen Hill and Lee Meadows made history by becoming the first two major-league pitchers to wear glasses while on the mound. The glasses seemed to help, as both went on to win 20 with the Bucs as Hill emerged victorious 22 times in 1927, while Meadows led the National League with 20 wins in 1926.

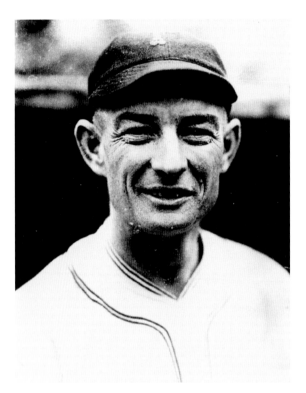

Wilkinsburg native Bill McKechnie took over the reins of the franchise in 1922, when Barney Dreyfuss named him to replace George Gibson. McKechnie helped bring the Pirates back up to the top of the pack in the game leading the Bucs to the 1925 world championship. Despite the fact he was fired in 1926 as part of the ABC episode, McKechnie amassed a team record .583 winning percentage.

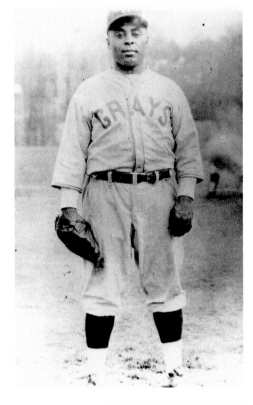

For 39 years, between 1915 and 1954, Oscar Charleston amazed baseball fans as one of the greatest players not only to grace the Negro League fields, but baseball diamonds of any kind. Charleston was a star for both the Grays and the Pittsburgh Crawfords and was a brilliant all-around hitter who also was a phenomenal defensive player. Charleston joined baseball's elite in 1976, with his election to Cooperstown.

CHAMPIONS AGAIN

Nearsighted pitcher Lee Meadows became the first major-league hurler ever to don glasses on the field of play in 1915. It did not exactly help Meadows at the beginning as he lost 23 games for the Cardinals in 1916. By the time he got to the Steel City in 1923, it was a different story. The North Carolina native went 88-52 in a Pirates uniform that included a magnificent 20-9 campaign in 1926.

Coming to the Pirates in a controversial trade that involved three popular Pirates in 1924, George Grantham quickly made Bucco fans forget Rabbit Maranville, Charlie Grimm, and Wilbur Cooper. The first baseman hit over .300 in each of his seven seasons with Pittsburgh, including a career high .326 in 1925.

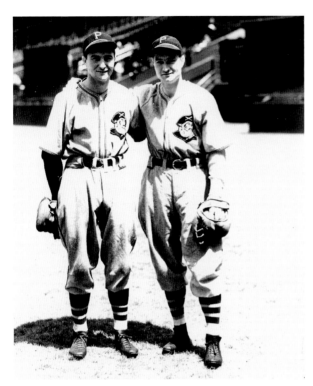

In 1926 and 1927, the Pirates added two outfielders from Harrah, Oklahoma, by the names of Paul and Lloyd Waner. During their first year together in 1927, Paul hit .380 and Lloyd chipped in with a .355 mark. The legend of the Waner brothers was born. By the time they were done, both were .300 hitters who had the honor of being the first brothers to be elected to the baseball hall of fame.

Nicknamed for his love of pies as a child, Harold "Pie" Traynor slipped through the grasp of his hometown Boston Braves and Red Sox, much to the delight of Pirates owner Barney Dreyfuss. One of the best third baseman in the history of the game, Traynor was at his best from 1925 to 1930 when he hit .342.

CHAMPIONS AGAIN

During the time he owned the Pittsburgh Pirates, Barney Dreyfuss made many brilliant decisions that led to the great success of the team throughout most of his tenure, getting rid of Hazen Shirley "Kiki" Cuyler was not one of them. Cuyler was an aggressive, splendid hitter who hit .357 in the Bucs world championship season of 1925, finishing second to the great Rogers Hornsby in the MVP race. Two years later, the 29-year-old outfielder was on the outside looking in. He first drew the ire of manager Donie Bush when Bush claimed that Cuyler did not hustle to first base on a groundball. Despite the fact he hit .309 in 1927, Cuyler was reduced to a bit player and was dealt to the Cubs in a very one-sided deal for Sparky Adams and Pete Scott.

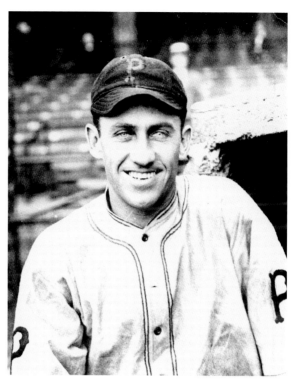

A hero of the 1925 World Series, pitcher Vic Aldridge went 15-7 in the regular season before having his finest moment in the fall classic. Aldridge emerged victorious in Game 2, in a tight 3-2 win by the Pirates. A few days later, with his club at the brink of elimination down three games to one, the Indiana native stopped Washington with a complete game 6-3 triumph.

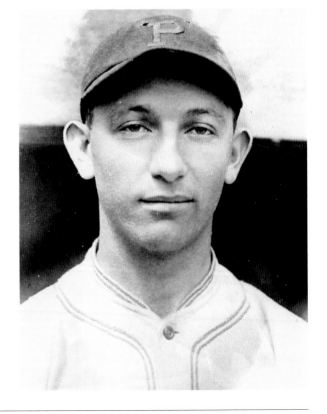

Clyde Barnhart was a slow, lumbering player for the Pirates in the 1920s, but boy could he hit. Barnhart hit over .300 on five occasions in his nine-year major-league career, all with the Pirates. His most complete season ever was during the Bucs' world championship run in 1925, when Barnhart drove in 114 runs while hitting .325.

CHAMPIONS AGAIN

The Pirates chose a young, aggressive yet volatile shortstop by the name of Dick Bartell over hall of famer Joe Cronin as the team's shortstop in 1928. Despite the fact he was only 160 pounds, the scrappy Chicago native hit over .300 in each of his three seasons in Pittsburgh, including .320 in 1930.

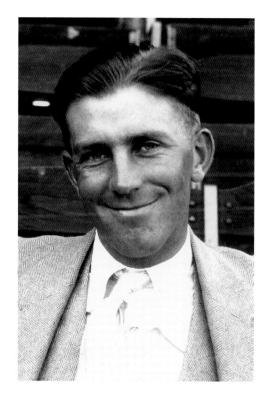

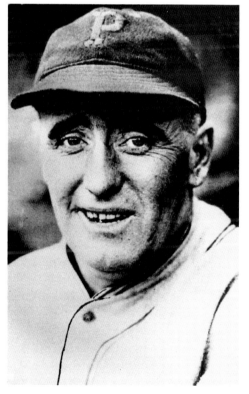

After the fallout of the infamous ABC incident in 1926, Donie Bush took over the reins of the Pittsburgh Pirates and led them to the National League pennant in 1927. Like Bartell, Bush had a bit of an explosive personality. Two years later, toward the end of the 1929 campaign, Bush resigned his post, finishing his career in the Steel City with a .580 winning percentage.

Breaking onto the Pittsburgh baseball scene in a big way, catcher Johnny Gooch hit .329 in his first full year with the Bucs in 1922. Gooch could do it all; a fine fielder and a consistent hitter, he was a pivotal part of both Pirates National League championships in the 1920s.

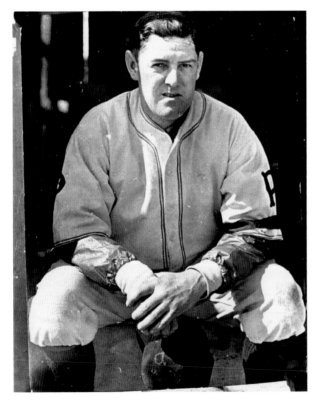

One of the winningest pitchers in Pirates history, Ray Kremer had a sparkling 143-85 career record. Twice he led the National League in ERA and wins, but it was his clutch performance in the 1925 World Series he will be remembered for. After pitching a complete game for a 3-2 win in Game 6, he pitched four innings of one-hit ball in Game 7, helping Pittsburgh to the world championship.

CHAMPIONS AGAIN

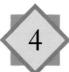

4

PIE, ARKY,

AND THE WANERS

1930–1939

Top five moments during the decade:

1. Babe Ruth hit the final three home runs of his remarkable career at Forbes Field, although the Bucs defeated his Boston Braves 11-7 on May 25, 1935.
2. Arky Vaughan won his only batting crown with a team record .385 average in 1935. His record still remains the all-time Pirates modern-day mark 71 years later.
3. On September 28, 1938, Gabby Hartnett hit the famed "Homer in the Gloamin" in the bottom of the ninth as the Cubs defeated the Pirates 6-5 and took over first place. Over the course of the month of September, the Bucs blew a seven-game lead.
4. On June 12, 1939, Honus Wagner was enshrined as part of the first class ever in the baseball hall of fame.
5. On May 12, 1932, Paul Waner hit four doubles, tying the major-league record. Waner went on to hit a National League record 62 doubles during this season.

Team of the decade:

Gus Suhr (first base)
Tony Piet (second base)
Floyd "Arky" Vaughan (shortstop)
Harold "Pie" Traynor (third base)
Woody Jensen (left field)
Lloyd Waner (center field)
Paul Waner (right field)
Al Todd (catcher)
Larry French (left-hander)
Bill Swift (right-hander)
Mace Brown (relief pitcher)

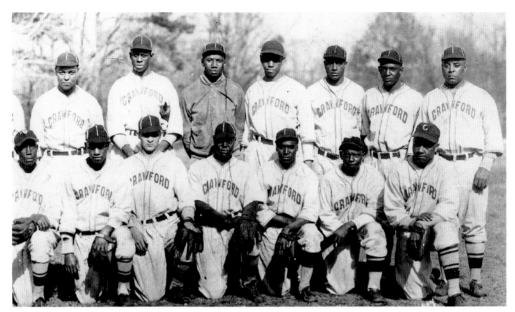

In 1932, the Pittsburgh Crawfords began an assault on Negro League baseball that eventually would see them assemble what is called the greatest Negro League team of all time in 1935. Owner Gus Greenlee would sign hall of famers Satchel Paige, Oscar Charleston, Judy Johnson, Cool Papa Bell, and Josh Gibson, capturing championships each season between 1933 and 1936.

In 1934, Pirates great Pie Traynor took over the reins of the club as a player manager. Traynor would have some success finishing his six-year tenure with a .530 winning percentage. Traynor took the team to the brink of a title in 1938 before the team collapsed in late September to the Cubs on the heels of Gabby Hartnett's infamous "Homer in the Gloamin."

While shortstop Dick Bartell was becoming one of the game's great young shortstops in the early 1930s, he was also becoming somewhat of a problem for the Pirates. Nicknamed "Rowdy Richard," his aggressive personality eventually wore thin on the Bucs. Despite the fact he hit over .300 for each of his three seasons as a Pirates starter, he was dealt to the Cubs following the 1930 campaign.

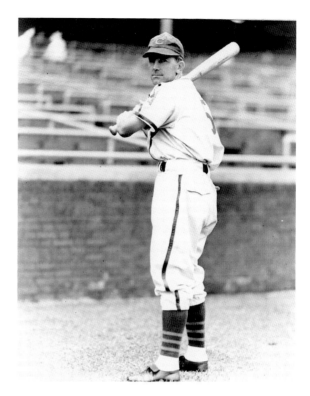

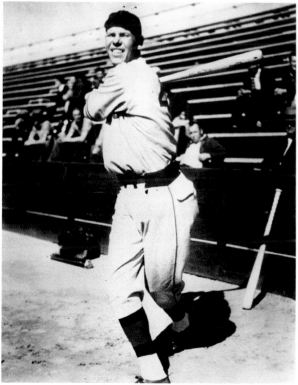

One of two players in major-league history who hit for the cycle on three occasions, Floyd "Babe" Herman came to the Pirates via a trade with the Cubs following the 1934 campaign. Herman, who ended up a .324 lifetime hitter, was at the back end of his career hitting only .235 in 81 at-bats before being sold to the Reds in June.

Through the 1930s, Paul Waner established himself as one of the game's all-time great players. Twice during the decade he led the league in hitting, .362 in 1934 and .373 in 1936. "Big Poison," as he was dubbed along with his brother Lloyd who was "Little Poison," set the National League record for doubles with 62 in 1932. Incredibly it would be one of three seasons where he eclipsed 50 doubles, as Waner's 605 doubles are 10th on the all-time list. Waner also rates among the game's best with a .333 career average, 26th all time while his 3,152 hits are 16th. With all the impressive totals he amassed over his long 20-year major-league career, Paul was honored with his induction to baseball's hall of fame in 1952.

PIE, ARKY, AND THE WANERS

After Barney Dreyfuss passed away tragically from pneumonia in 1932, his son-in-law Bill Benswanger took over the everyday operations of the team. A patron of the Pittsburgh Symphony, Benswanger ran the team with some success, although he did not quite reach the levels of Dreyfuss, never bringing a championship to the city in his 15-year tenure.

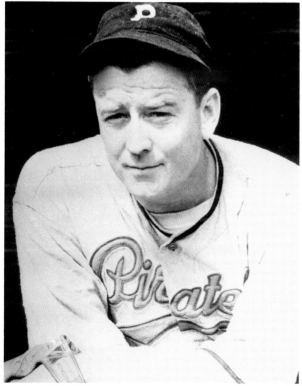

Cy Blanton had a phenomenal rookie campaign in 1935 for Pittsburgh, winning 18 games while leading the National League in ERA with a 2.58 mark. Blanton, a two-time All-Star, won 56 games in his first four full seasons for the Bucs before signing with the Phillies as a free agent in 1940. Sadly Blanton passed away in a mental hospital at the age of 36 in 1945.

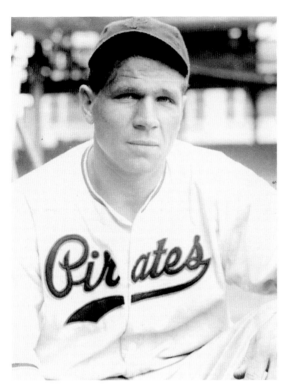

Proclaiming himself as the "ugliest man in baseball," Johnny "Ugly" Dickshot patrolled the outfield for Pittsburgh between 1936 and 1938. In his most productive season in a Pirates uniform, Dickshot hit .254 in 236 at-bats in 1937. His finest campaign was his last in 1945 when he hit .302 for the Cubs. After his retirement, Johnny ran a tavern called The Dugout.

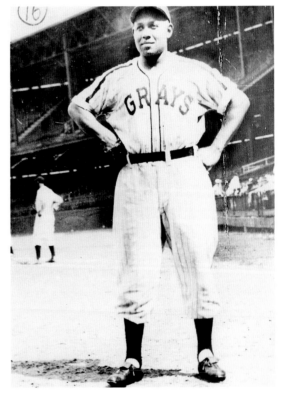

When talking about the most consistent hitters in the annals of professional baseball, perhaps the most consistent would be Walter "Buck" Leonard. Leonard was a devastating line-drive hitter who hit .335 in his long Negro League career. He spent all but one season with the Grays, a Negro League record 17 seasons. He was selected to his rightful spot in the hall of fame in 1972.

Jewel Winklemeyer Ens got his opportunity to manage in the majors, replacing the irascible Donie Bush in 1929. Ens spent two unspectacular seasons with the Bucs, finishing in fifth place both years before George Gibson replaced him in 1931. Ens went on to have a long career as a major-league coach and minor-league manager. He died of pneumonia in 1950 while he was managing the Syracuse Chiefs.

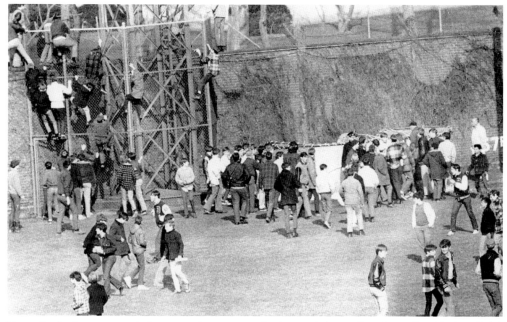

Fans climb the massive light tower that was at the base of the wall in legendary Forbes Field. Perhaps one of the most memorable moments in the park happened on May 25, 1935, when Babe Ruth hit three phenomenal home runs, the last of which was the first ever to clear the right-field roof. They would be the final three home runs of the Bambino's memorable career.

THE PITTSBURGH PIRATES

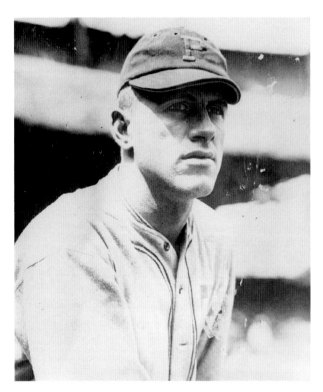

One of the court jesters of baseball, Charlie "Jolly Cholly" Grimm, was also a pretty solid first baseman for the Bucs in the 1920s. Grimm, who hit a career high .345 in 1923, clashed with the Bucs' humorless owner Barney Dreyfuss, who traded Grimm and his fellow comedian Rabbit Maranville in 1924. Grimm made the Bucs pay, playing with Chicago until 1936 and hitting .290 for his career.

A .279 career hitter who is arguably the best fielding first baseman in Pirates history, California's Gus Suhr had a memorable nine-and-a-half-year Pittsburgh career that included two National League records. The first was a 70-game errorless streak at first in 1936; the second was 822 consecutive games played in a streak that ended on June 5, 1937, when he left to attend his mother's funeral.

Honus Wagner was without question the greatest player ever to don a Pirates uniform, and on June 12, 1939, he was given the ultimate honor when he was part of the inaugural class ever to be inducted into the hall of fame. Wagner gave a concise yet memorable speech that day as he entered the hallowed halls with the likes of Babe Ruth, Ty Cobb, Walter Johnson, Grover Alexander, Napoleon Lajoie, George Sisler, Eddie Collins, Tris Speaker, Cy Young, and Connie Mack. In the lower picture, Wagner stands in the middle between two other legends, Sisler (left) and Pie Traynor (right), who would enter the hall of fame himself in 1948.

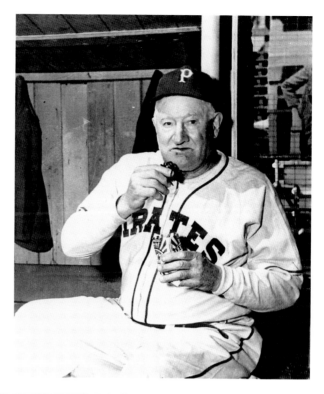

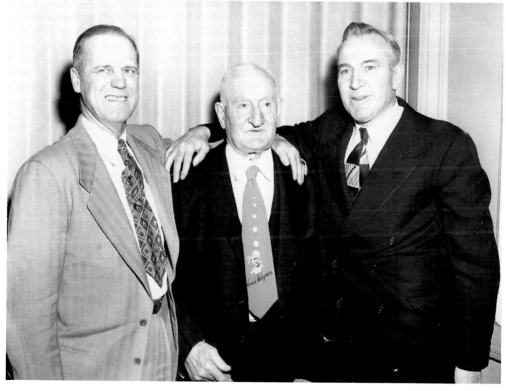

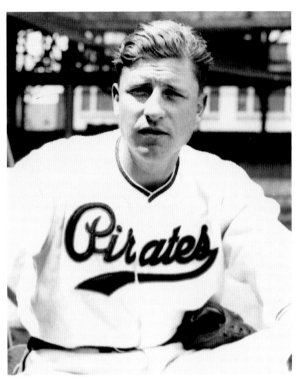

Nicknamed "Woody" due to his first name combined with the fact he was from the state of Washington and played in the Timber League, Forrest Jensen was the least known of the Pirates outfielders in the 1930s. Playing alongside the Waner brothers, Jensen was a .285 career hitter who set the major-league record for at-bats in a season with 696 in 1936.

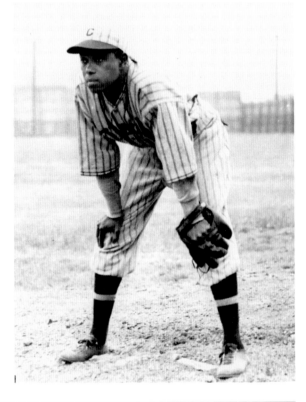

A consistent, dazzling third baseman who was one of the Negro League's premiere clutch hitters, Judy Johnson was also a leader, captaining the great Crawford teams of the mid-1930s. After his brilliant 19-year career came to end in 1936, Johnson eventually became a scout in the majors, signing such superstars as Dick Allen and Bob Bruton. Johnson was elected to Cooperstown in 1975.

PIE, ARKY, AND THE WANERS

Josh Gibson said about James "Cool Papa" Bell, "Cool Papa Bell was so fast he could get out of bed, turn out the lights across the room and be back in bed under the covers before the lights went out." Bell was considered one of the fastest players in baseball history who also excelled both at the plate and as a center fielder. He was enshrined in the hall of fame in 1974.

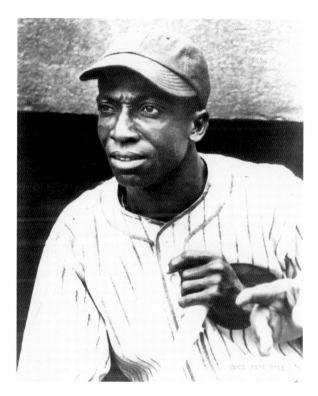

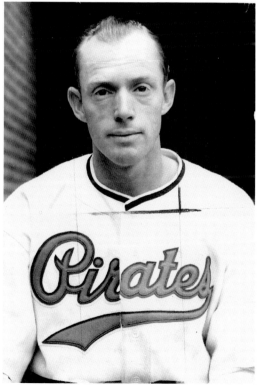

After driving 82 runs in his first year as the Bucs' regular second baseman, Lemuel "Pep" Young held on to the starting job for four seasons between 1935 and 1938. Young stumbled a little bit in 1939 and 1940 and then was dealt to Atlanta of the Southern Association for Alf Anderson.

Breaking into the Bucs' starting spot at shortstop in 1932, Floyd "Arky" Vaughan hit .318 during his rookie campaign. Arky was the model of consistency during his Pirates career, never hitting below .300 while being selected to play in eight consecutive All-Star Games. Vaughan's marquee season was in 1935 when he led the league with a .385 average, a mark that still stands today as the modern-day Pirates record.

There were few players in the history of the game that were better than Josh Gibson. A powerful slugger for the Grays and Crawfords, who hit a reported 962 homers in his career, Gibson was as solid behind the plate defensively as he was an offensive legend. Unfortunately Gibson would die at the age of 35 from a stroke, never living his dream of playing in the majors.

THE WAR YEARS

1940–1949

Top five moments during the decade:

1. Ralph Kiner became the first National League player to eclipse 50 home runs when he hit his historic blast on September 19, 1949, against the Giants. His 54 home runs gave him his fourth consecutive National League crown and is a Pirates single-season record that remains today.
2. On August 7, 1946, the Pirates were sold by the Dreyfuss family to a group that included realtor John Galbreath and singer Bing Crosby.
3. On September 12, 1947, Ralph Kiner ended an unbelievable four-game run where he hit a record eight home runs in that time period.
4. The Pirates made Hank Greenberg the National League's first $100,000 player in 1947.
5. Arky Vaughan hit two home runs in the 1941 All-Star Game.

Team of the decade:

Elbie Fletcher (first base)
Frankie Gustine (second base)
Floyd "Arky" Vaughan (shortstop)
Bob Elliott (third base)
Ralph Kiner (left field)
Vince DiMaggio (center field)
Wally Westlake (right field)
Al Lopez (catcher)
Fritz Ostermueller (left-hander)
Truett "Rip" Sewell (right-hander)
Xavier Rescigno (relief pitcher)

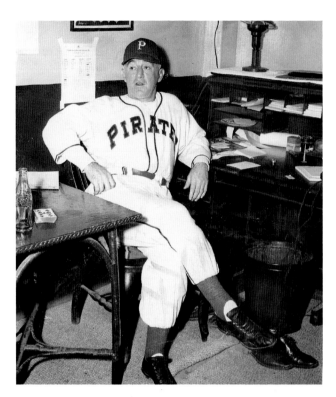

Managing the Pittsburgh Pirates during the 1940s was hall of fame second baseman Frankie Frisch. Frisch, who led the famous gashouse gang in St. Louis to the world championship in 1934, was hired as Pirates manager in 1940, replacing another hall of famer, third baseman Pie Traynor. Frisch, who was an aggressive, argumentative manager, spent seven years at the helm of the Pirates, finishing with a 539-528 mark.

Purchased from Boston prior to the 1940 campaign, Debs Garms proved to be quite an astute pickup; he won the National League batting crown with a .355 mark. Garms gets his title under controversy as he only had 358 at-bats. While the American League had a requirement for 400 at-bats to qualify for their title, the National League stated a player only has to appear in 100 games.

Vince DiMaggio looks on as third baseman Bob Elliott scores in the picture at the bottom of the page. Elliott was the best Pirates offensive player in the first half of the 1940s, knocking in over 100 runs three times between 1943 and 1945, finishing second in the circuit the first two years. A four-time All-Star during his tenure in a Pirates uniform, "Mr. Team," as he was known, was inexplicably traded to the Braves in 1947 where he immediately had his best season ever, being named National League MVP. Elliott went on to briefly manage the Kansas City Athletics to a last-place finish in 1960. Six years later, the San Diego native died in his hometown at the age of 49 when he ruptured a vein in his windpipe.

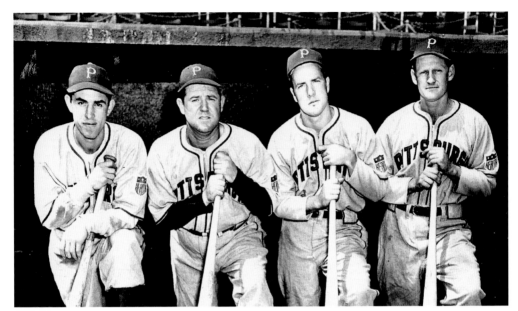

The meat of the Pittsburgh Pirates offense during the early 1940s is pictured above. From right to left is two-time All-Star center fielder Vince DiMaggio, Joe's older brother; fine-hitting catcher Babe Phelps, a .310 career hitter who was a three-time All-Star; first baseman Elbie Fletcher; and slugging third baseman Bob Elliott, the 1947 MVP while with the Braves.

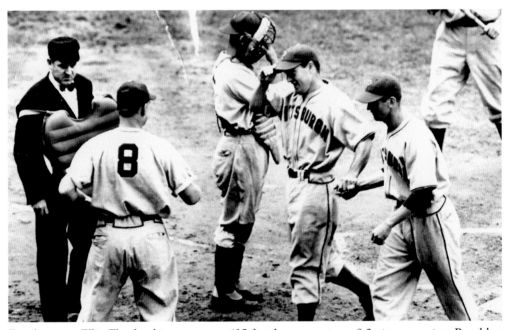

First baseman Elbie Fletcher hits a monster 425-foot home run in an 8-2 victory against Brooklyn on July 8, 1943. Fletcher, an All-Star in 1943 for the only time in his career, got his shot to play in the majors in rather a unique way. He earned a tryout with the Braves by winning a newspaper contest in Boston after his family initiated a write-in campaign on his behalf.

THE WAR YEARS

Lee Handley was a fine-hitting third baseman and a tough individual who survived two serious injuries. The first was in 1939 when he was beamed, the second was in an automobile accident in 1941 in which he suffered a gash over his head and hurt his right shoulder severely. He eventually returned to the Bucs in 1944 after being out of the game for two years.

After 10 consecutive seasons where he batted over .300 for the Pittsburgh Pirates, hall of fame shortstop Arky Vaughan was traded to the Brooklyn Dodgers in 1941. Eleven years later in 1952, Vaughan died tragically at the age of 40 after he went into a lake to try and save a friend who had fallen out of their fishing boat. Vaughan, who could not swim, and his friend unfortunately drowned.

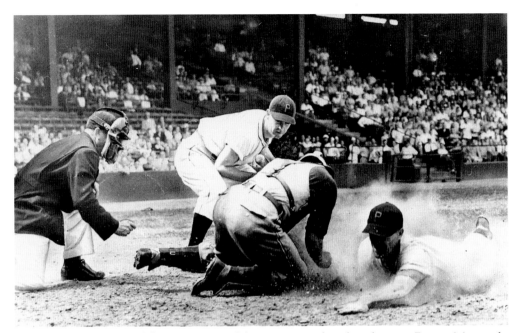

Before he became one of the most successful managers in franchise history, Danny Murtaugh, sliding safely into home in the picture, was a fine second basemen. After leading the league in stolen bases for the Phillies in 1941, Murtaugh came to the Bucs in 1948 where he hit .290 and led the league in double plays, putouts, and assists, finishing ninth in the MVP race.

Frankie Zak's career only totaled 123 games over three seasons, but in 1944, he became the most unlikely All-Star in the history of the mid-summer classic. The game was held in Pittsburgh that season, and National League manager Billy Southworth wanted Pirates shortstop Pete Coscarart on the team. Coscarart was on a fishing trip so Southworth chose his backup Frankie Zak, who was already in town, to replace him.

A packed house at Forbes Field sings the national anthem prior to a ball game. This time-honored tradition took on a special meaning during World War II. While millions were off to fight in the great battle, those who remained behind needed activities such as baseball to give the country a much-needed morale boost during such dire times.

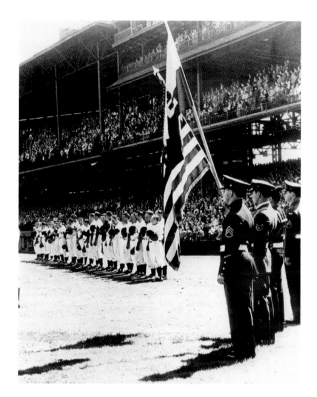

Maurice "Bomber" Van Robays came to the Bucs in 1939, replacing the great Lloyd Waner as the Pirates outfielder. Van Robays immediately paid dividends, knocking in 116 in 1940. While he never reached those heights again, the Detroit native did notch a spot in Bucco history when he was credited with naming Rip Sewell's famous pitch the "Eephus Pitch."

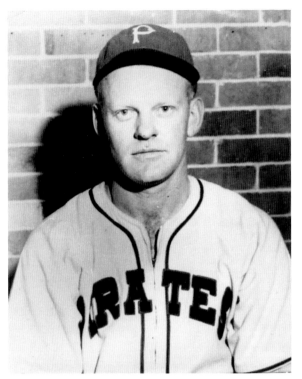

After having part of his foot blown off in a hunting accident, Rip Sewell was unable to serve his country during World War II. Luckily the accident did not prevent Sewell from becoming one of the game's best pitchers during the war years when he was named the Pitcher of the Year in 1943. Sewell also was famous for his "Eephus Pitch," a high, slow, blooping pitch that caught many batters unaware.

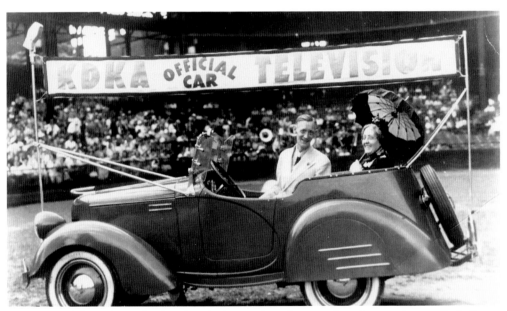

The original legend in the Pittsburgh Pirates broadcasting booth was the smallish Rosey Rowswell. From 1936 to 1955, Pittsburgh fans were thrilled to hear one of the first of the so-called "homer" announcers. His most famous saying was his memorable home run call when he proclaimed "raise the window Aunt Minnie" when his partner would drop a tray making the sound of broken glass after a Pirates long ball.

An All-Star for the Brooklyn Dodgers in 1940, Pete Coscarart came to the Pirates following the 1941 campaign as part of the infamous Arky Vaughan trade. Even though he was a solid player, the California native proved to be no replacement for Vaughan, hitting .228 for the Bucs in 1942 after replacing the hall of famer.

When the Pirates gave up one of the team's best hitters, Bob Elliott, for future hall of famer Billy Herman after 1946, they thought they were not only getting a great player but a solid manager to replace Frankie Frisch; they got neither. Herman hit only .213 in what would be his final season while leading the Pirates to a last-place finish, being replaced before the season ended.

THE PITTSBURGH PIRATES

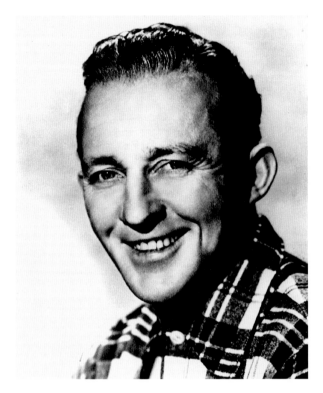

Part of the ownership group that bought the Pittsburgh Pirates in 1946 was the renowned actor/singer Harry "Bing" Crosby. Crosby, who starred in 79 films and made over 1,700 recordings, was one of the biggest grossing movie stars and singers in history. His movies sold over one billion tickets, third best of all time, while an incredible 41 of his songs hit No. 1 on the charts.

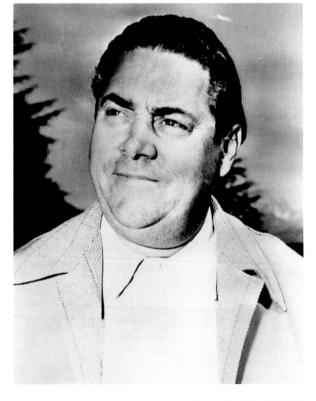

The first general manager in Pittsburgh Pirates history was H. Roy Hamey. A former president of the American Association, Hamey was hired to run the club after the John Galbreath group bought the team in 1946. During his five-year tenure, Hamey signed the National League's first $100,000 man in Hank Greenberg and also made several destructive trades that led to the team's poor run in the 1950s.

In 1947, Pittsburgh made Hank Greenberg the first $100,000 player in National League history when they signed him to the lucrative contract. That season would prove to be the last in the two-time MVP's hall of fame career. Even though his time with the Pirates was brief, he earned his money smacking 25 home runs while helping a young slugger by the name of Ralph Kiner become a legend.

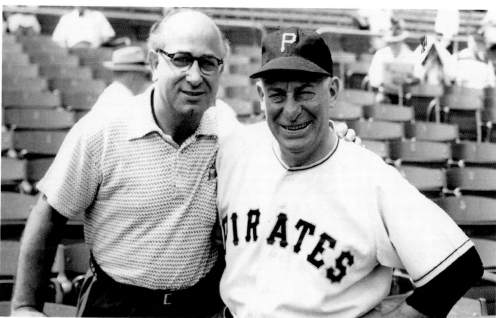

In 1948, Billy Meyer was hired to manage the Pirates. He was an immediate success, leading the team to a surprising 83-71 mark, winning the Sporting News Manager of the Year in the process. He would never reach those heights again, as he was fired four years later. Despite the sub-500 record, Meyer was only the second person in Pirates history to have his number retired.

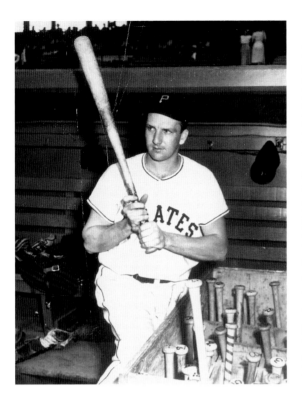

In the late 1940s, the two preeminent sluggers in the National League were Ralph Kiner and the Giants' Johnny Mize (pictured in the lower photograph). In 1947 and 1948, they tied for the league lead in homers with 51 and 40 respectively. Kiner broke the two-year struggle in 1949, winning the league title outright with 54 round-trippers. For his career Kiner was the greatest power hitter in franchise history. He led the league in homers an unprecedented seven times and is the only Pirate ever to eclipse the 50 home run mark, which he did twice. He retired with the second-best home-runs-per-at-bat figure in history (1 for every 14.1 at-bats) behind Babe Ruth. Twenty years after his retirement, Kiner got his just reward, being elected to the baseball hall of fame.

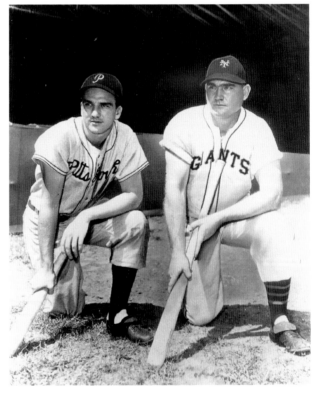

A fiery character who did everything from fight with Ernest Hemingway, to tell Dodger management he did not want to be on the same team with Jackie Robinson, Kirby Higbe was dealt to the Pirates early in 1947 following his dispute over playing with Robinson. The two-time All-Star was past his prime when he reached the Steel City, going 19-26 in two-plus seasons.

Called the "Thomas Edison of the mound" because of the six pitches he used, Murry Dickson was definitely a diamond in the rough on some bad Pirates teams. In 1951, the Missouri native went 20-16 on a club that finished 64-90. Despite the fact Dickson lost 60 games over the next three years, he was selected to play in the 1953 All-Star Game, earning a save in the process.

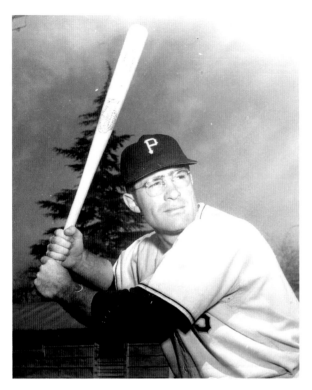

Perhaps the poster boy for fleeting fame in baseball is Dino Restelli. Restelli came to the Bucs in 1949 from the San Francisco Seals and looked like the second coming of Babe Ruth, hitting seven home runs in his first 39 at-bats. Once pitchers discovered Dino could not hit a curve, his days were numbered, as he was out of the majors by 1951.

Ernie "Tiny" Bonham was by no means a tiny man at six feet, two inches and 215 pounds. After a fine career as the Yankee ace during World War II that included a 21-5 mark in 1942, Bonham came to the Bucs in 1947. Two years later, he developed appendicitis and underwent surgery; it was an operation he would not survive as he died on September 15, only 18 days after his final start.

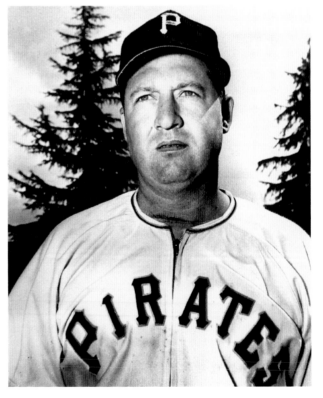

THE WAR YEARS

THE BASEMENT YEARS

1950–1959

Top five moments during the decade:

1. On May 26, 1959, Harvey Haddix pitched the greatest game ever, losing his perfect game and the victory in the 13th inning against the Milwaukee Braves.
2. Dale Long set a record that, while tied, has never been broken in 50 years by homering in eight consecutive games in 1956.
3. Roy Face won a record-setting 17 consecutive games in a phenomenal 18-1 season in 1959.
4. In 1954, the Pirates drafted a young Puerto Rican outfielder from the Dodgers organization who would turn out to be the foundation that the team would be built on, a player by the name of Roberto Clemente.
5. Ralph Kiner hit a National League–best 47 homers in 1950 and captured the Sporting News Player of the Year Award.

Team of the decade:

Dale Long (first base)
Bill Mazeroski (second base)
Dick Groat (shortstop)
Frank Thomas (third base)
Ralph Kiner (left field)
Bill Virdon (center field)
Roberto Clemente (right field)
Clyde McCullough (catcher)
Harvey Haddix (left-hander)
Bob Friend (right-hander)
Roy Face (relief pitcher)

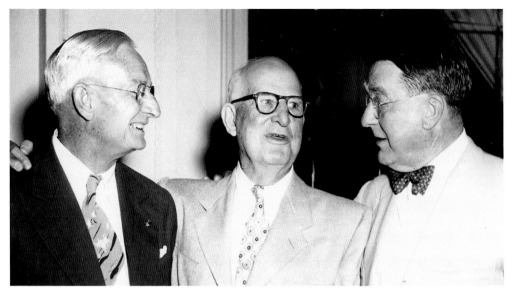

Branch Rickey was the inventor of the farm system, the man who changed the face of professional sports when he signed the first African American to play in the major leagues during the 20th century in Jackie Robinson. He was also the man John Galbreath entrusted the future of the Pirates with in 1950. Rickey was a shrewd dealer who brought the promise of championships to Pittsburgh. By the time he stepped down five years later, he had five last-place finishes and three 100-loss seasons to his credit. Even though his tenure was disappointing, Rickey, pictured with Bill McKechnie and Fred Clarke in the top picture and addressing one of his Pirates clubs below, did contribute some important pieces to the franchise in Bill Mazeroski, Roberto Clemente, Vern Law, Dick Groat, and Bob Friend.

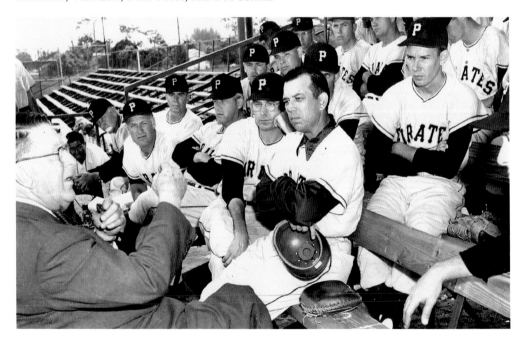

In a rather undistinguished career where he amassed a 48-53 record, Oregon's Cliff Chambers did have his day in the sun, etching his name in the Pirates record books on May 6, 1951. That day he threw the second Pirates no-hitter of all time, beating the Boston Braves 3-0. Chambers was wild though, walking eight and tossing one wild pitch.

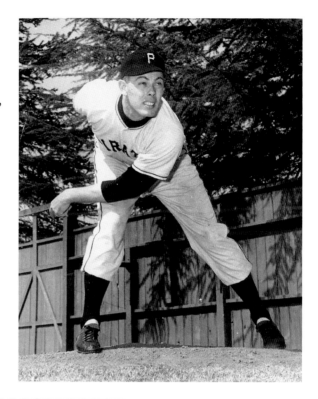

Playing two stints with the Pirates in 1950 and 1952, John Berardino was an average yet versatile infielder who was dubbed the "one man infield." He would have been nothing more than a footnote in Bucco history if not for his career choice after baseball, as Dr. Steve Harvey in the soap opera *General Hospital*—a part he played for 25 years.

Another Pirate who was more famous off the field than on, catcher Joe Garagiola was not exactly a hall of fame talent for the Bucs in the early 1950s. Although he did hit .316 in the 1946 World Series, it was behind the mic where Garagiola would find his fame as the witty baseball announcer for NBC as well as the host of the *Today Show*.

The precursor to Bo Jackson, Vic Janowicz won the Heisman Trophy in 1950 for Ohio State before choosing a career in major-league baseball. Bo Jackson he was not, unfortunately, as he hit only .214 in parts of two seasons with the Pirates. Janowicz returned to football with the Redskins following his short stint in Pittsburgh.

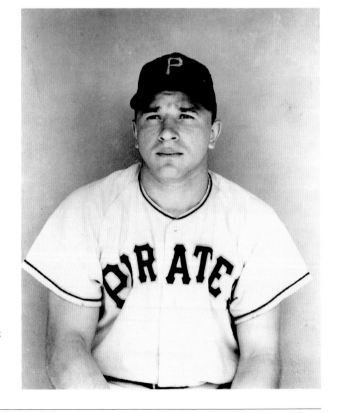

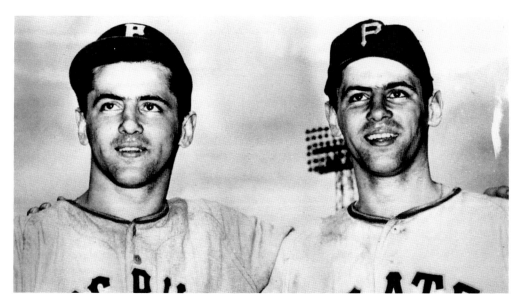

Not quite as successful as the Waner brothers on the diamond, the Pirates did sport a pair of brothers in the 1950s, twins to be exact, John (left) and Eddie (right) O'Brien. Unfortunately the O'Brien's were more adept at basketball then baseball. John set the all-time NCAA scoring record at Seattle with 3,302 points, becoming the first player with 1,000 points in a season, while Eddie had 1,613 points.

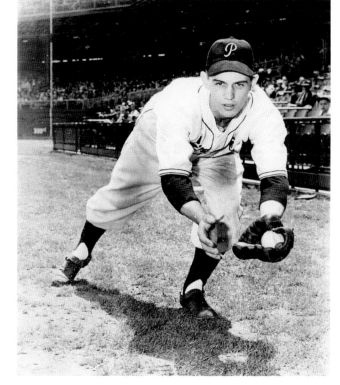

One of a long line of players during the 1940s and 1950s who were more successful at other endeavors off the field than they were on, Gene Mauch's path to glory was on the bench as a fine manager. A bit player in the majors who was with the Bucs in 1947, Mauch managed several teams over 26 seasons, winning 1,902 games.

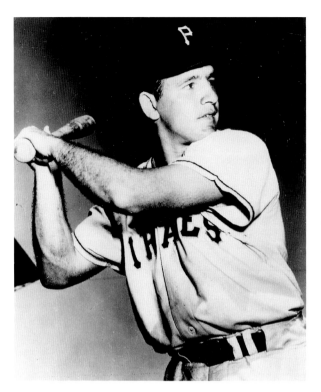

A hometown hero from the Hill District, Bobby Del Greco came to the Pirates with high hopes in 1952; his high hopes were dashed almost immediately. The slick-fielding center fielder hit only .217. He would not return to Pittsburgh until 1956 where, after hitting two home runs in a game against the Cardinals, general manager Joe Brown was able to trade him to St. Louis for another center fielder, Bill Virdon.

For those who lament about Pirates ownership today and the current losing era of Pirates baseball, take heart, from the time John Galbreath and his group took over in 1946 until 1958, the Bucs were much worse. Pirates teams went 608-931 during the first 10 years he owned the team. Things got better as the club would win three world championships over the next 21 years.

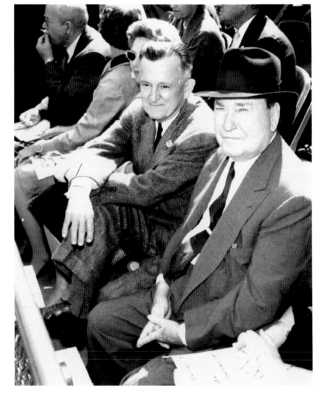

THE BASEMENT YEARS

Some of the most impressive power hitters for the Pirates during the 1950s were, from left to right, Dick Stuart, Dale Long, and Frank Thomas. Stuart smacked 66 blasts in the minors in 1956 and 85 for the Bucs between 1959 and 1961. Long hit 27 homers including a record of homering in eight consecutive games in 1956, while Thomas clouted 30 in his first full season in 1953.

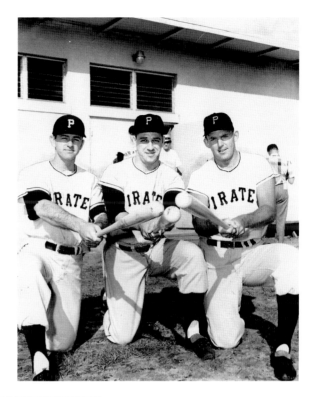

Longtime legendary Pittsburgh newscaster Paul Long spent six seasons in the Pirates booth between 1957 and 1962. A sportscaster for KDKA-TV, Long was the third man in the booth with hall of famer Bob Prince and Jim "Possum" Woods. Long jumped to WTAE-TV in 1968 as the evening anchor, where his memorable voice was on the air until he was almost 80 years old.

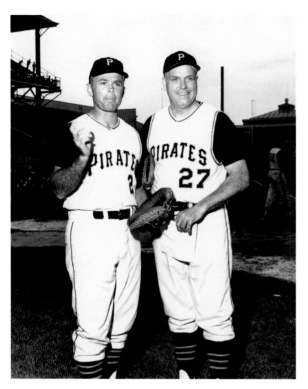

A star player for the Pittsburgh Pirates during the 1940s, Frankie Gustine retired from the game in 1950. Through his 12-year major-league career, the .265 hitter was selected to play in three All-Star Games between 1946 and 1948, the first at second and the final two at third. Gustine, a popular figure in Pittsburgh, had part ownership in the Sheraton Inn at Station Square on the city's south side.

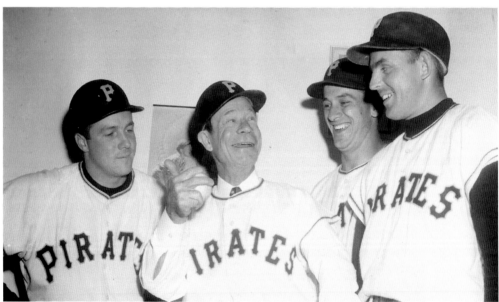

Comedian Joe E. Brown (second from the left) is surrounded by, from left to right, Bob Friend, Dale Long, and Frank Thomas. Brown was a great baseball fan, starring in three baseball films and owning the minor-league Kansas City Blues. Between 1928 and 1964, Brown starred in 66 films and his own television show in 1955. He also happened to be the father of Bucco general manager Joe L. Brown.

Bobby Bragan (batting) was hired by Joe Brown (catching) to manage the Bucs in 1956. While a very innovative manager, Bragan was also very volatile, picking many arguments with umpires. His most memorable came in 1957. After being ejected for an obscene gesture, he reappeared with a glass of orange juice and a straw for the umpires to drink. Danny Murtaugh replaced him as manager later that season.

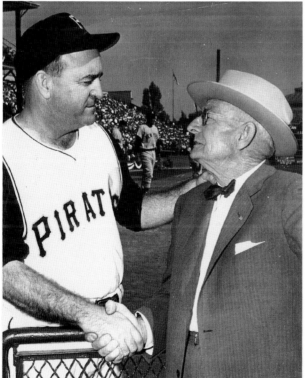

Chatting before a game at Forbes Field are two of the greatest managers in team history, Danny Murtaugh (left) and Bill McKechnie. Murtaugh became arguably the greatest manager in the history of the franchise, winning 1,115 games and two world championships while McKechnie, a hall of famer, had a spectacular .583 winning percentage leading the Bucs to the 1925 title.

Perhaps no one was more responsible for the success the Pittsburgh Pirates enjoyed for most of the 1960s and 1970s than scout Howie Haak. Haak, a disciple of Branch Rickey, harvested baseball talent from Latin America at a time when no one else was adept at doing it. His contributions included Manny Sanguillen, Rennie Stennett, Tony Pena, and a hall of famer by the name of Roberto Clemente.

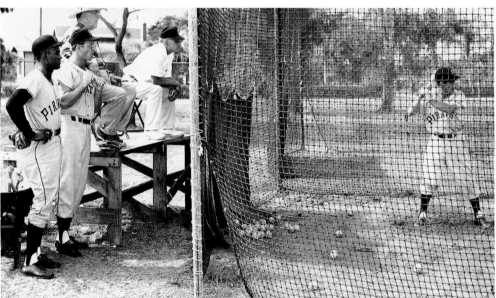

Roberto Clemente, left, was stolen from Brooklyn in the 1954 minor-league draft. While many have always stated that the Dodgers were hiding him in the minors, often not playing him in clutch situations so teams would not draft him, the Society for American Baseball Research's Stew Thornley, through his research, states that they did not hide him, they had a glut of outfielders and Clemente did not hit well against right-handed pitching that year.

THE BASEMENT YEARS

Shown in an interview in the top photograph and tossing a ball in the bottom (left in both) Roy "the Baron" Face was among the first true relief pitchers in the game. Drafted from the Dodgers organization in 1952, Face quickly became an outstanding reliever. A three-time All-Star who made the forkball his bread-and-butter pitch, Face set the sport on its ear in 1959, winning 17 games in a row while posting an 18-1 mark with what is a current record .947 winning percentage. Face was the first pitcher to ever save three games in a World Series, which he did in the 1960 fall classic.

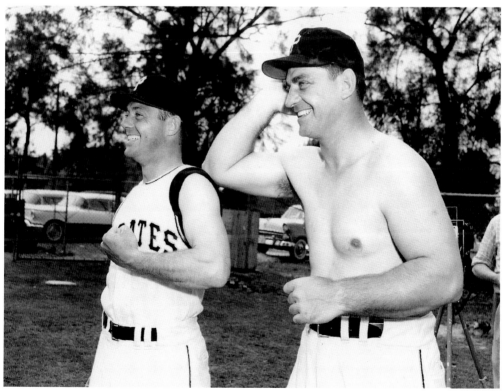

Nicknamed "the Warrior," Bob Friend's statistics may have suffered from the poor teams he played on as he compiled a 197-230 mark, but there were few pitchers who were as effective. He became the first player ever to lead the league in ERA with a last-place team in 1955. Once the Pirates began to improve, Friend's statistics improved as he posted a league-high 22 wins in 1958.

An elder in the Mormon Church, which prompted his nickname "the Deacon," Vern Law was recommended to Pirates part-owner Bing Crosby by Idaho senator Herman Welker. Pittsburgh signed the right-hander in 1948. After fulfilling a two-year military obligation in 1952 and 1953, Law became an important member of the starting rotation, going 18-9 in 1959, a precursor to the greatness he was about to achieve.

THE BASEMENT YEARS

One of Branch Rickey's greatest signings, Bill Mazeroski was inked by the Bucs out of high school in 1954. Considered one of the best defensive second baseman of all time if not the best, the seven-time All-Star took a stranglehold on the Pirates second base spot two years later in 1956 were he was the cornerstone of the Bucco infield for most of his 17-year career.

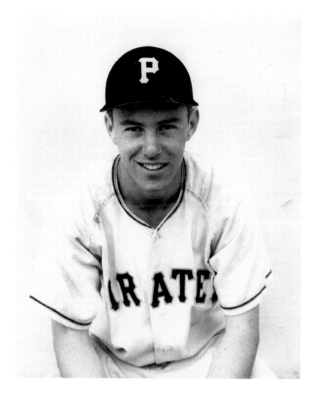

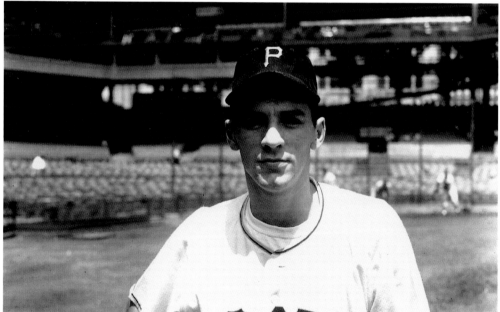

A Wilkinsburg native, few would have guessed that Dick Groat would have been the National League MVP when Branch Rickey signed him out of Duke in 1952. Groat's forte with the Blue Devils was basketball as he was a two-time All American, the 1952 UPI Basketball Player of the Year, and the first basketball player ever to have his number retired at the school.

A two-time All-Star from LaJolla, California, Bob Skinner was a fine left fielder who hit .300 four times over the course of his 12 years in the major leagues. Perhaps the apex of Skinner's career was in 1958 when he hit .321 with 70 RBIs. Skinner later went on to manage for the Phillies and Padres before returning to the Steel City as a coach in 1979.

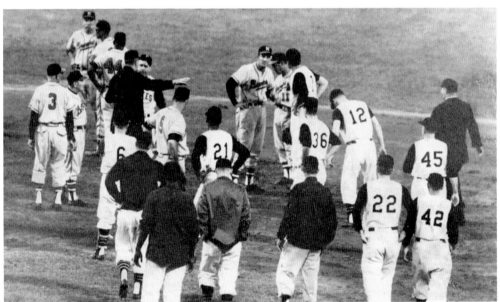

Harvey Haddix had a fine career winning 136 games, but it was his performance on May 26, 1959, where he pitched the greatest game in the history of the sport that made Haddix a legend. That night in Milwaukee, he faced 36 batters and set 36 batters down, throwing 12 perfect innings. Unfortunately the 13th would not be lucky for Harvey as the Braves scored the game's only run, winning the contest 1-0.

THE BASEMENT YEARS

BACK ON TOP

1 9 6 0 – 1 9 6 9

Top five moments during the decade:

1. On October 13, 1960, Bill Mazeroski hit the most dramatic home run in World Series history, smacking a shot over the left field Forbes Field wall in the bottom of the ninth in Game 7 to give the Bucs an improbable 10-9 win over the Yankees and their first title in 35 years.
2. In 1969, Roberto Clemente captured his ninth consecutive Gold Glove Award. Clemente also won four batting titles in the decade, 1961, 1964, 1965, and 1967, and the 1966 MVP Award.
3. Pittsburgh won four major awards in 1960 as Dick Groat won the MVP while Vern Law took the Cy Young Award, Bill Mazeroski captured the Sporting News Major League Player of the Year, and Danny Murtaugh was named the Sporting News Manager of the Year.
4. Bob Moose tossed a no-hitter against the eventual world champion New York Mets on September 20, 1969. Moose brought his record to 12-3 as the Pirates won 4-0.
5. On August 5, 1969, Willie Stargell hit a majestic titanic blast becoming the first player ever to hit a ball out of Dodger Stadium. The blast measured 512 feet.

Team of the decade:

Donn Clendenon (first base)
Bill Mazeroski (second base)
Dick Groat (shortstop)
Don Hoak (third base)
Willie Stargell (left field)
Matty Alou (center field)
Roberto Clemente (right field)
Smoky Burgess (catcher)
Bob Veale (left-hander)
Vern Law (right-hander)
Roy Face (relief pitcher)

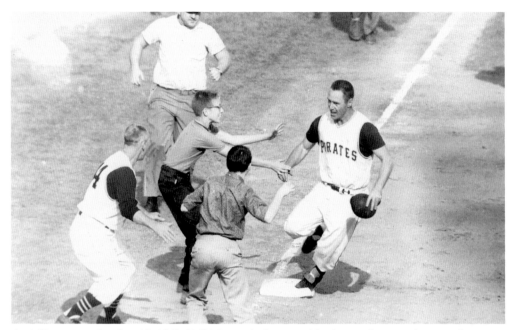

At 3:37 p.m. on October 13, 1960, Bill Mazeroski hit arguably the single most dramatic homer in baseball history when he smacked one over the left field wall in the bottom of the ninth to give Pittsburgh a 10-9 Game 7 victory over the Yankees. The Bucs, who were huge underdogs in the series and were outscored 38-3 in their three losses, blew a 9-7 lead in the top of the ninth inning. Wasting no time, Mazeroski led off the bottom of the ninth against Ralph Terry with the series-winning home run, giving the franchise its first championship in 35 years. In the top photograph, Mazeroski rounds third into the grasp of very excited Pirates fans, who are waiting for him en masse at home plate in the bottom photograph, as he is on his way to score the legendary run. Mazeroski still remains the only man in baseball history to hit a World Series Game 7 walk-off home run.

Danny Murtaugh (left) and catcher Hal Smith celebrate after the Bucs won the 1960 World Series. Replacing Smoky Burgess in the eighth inning of Game 7 after the popular catcher was removed in the seventh inning with a pinch runner, Smith etched his name in Pirates lore, hitting a three-run homer in the bottom of the eighth, giving Pittsburgh a temporary 9-7 lead.

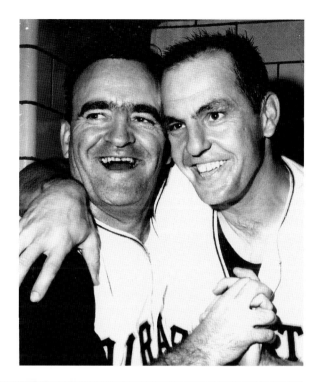

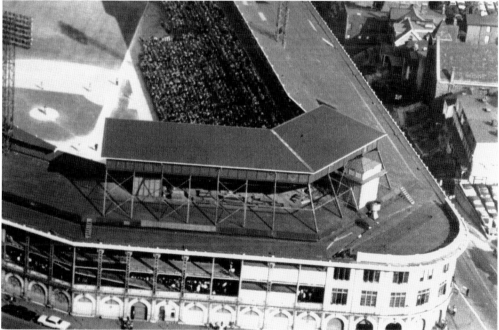

While the historic facility would be empty 10 years later in favor of Three Rivers Stadium, in 1960, Forbes Field was hopping. With fans coming in record numbers, the Pirates drew 1,705,828 at the gate during that dramatic championship season. It was a franchise record that held up for 28 years until the 1988 club eclipsed 1.8 million.

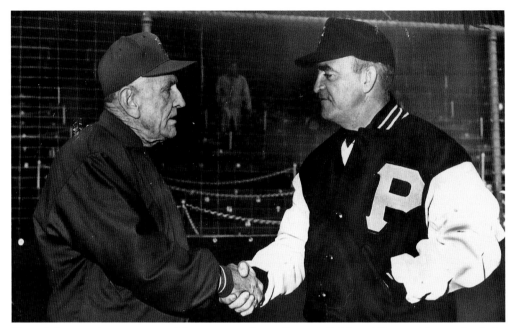

Two of the game's most successful managers, Casey Stengel (left) and Danny Murtaugh, shake hands before the 1960 World Series. Between the two they won 3,020 games, nine World Series, 12 league championships, and four division championships. While the majority of championships went to Stengel, Murtaugh had a better winning percentage, .540 to .508, and did win their only head-to-head post-season matchup.

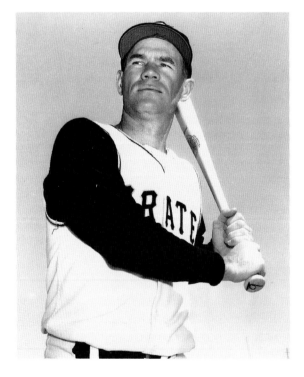

A World War II vet, Rocky Nelson was a minor-league legend, winning the Triple Crown twice in the International League, a circuit where he was named MVP three times. A bench player for most of his major-league career, Nelson's best moment in Pittsburgh had to be in Game 7 of the 1960 World Series when the slugger smacked a first-inning homer, giving Pittsburgh a 2-0 lead.

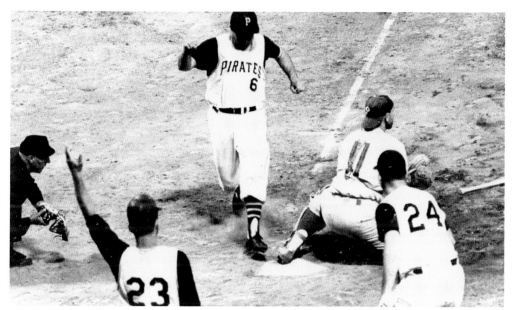

Lumbering catcher Forrest "Smoky" Burgess, who came to the Bucs in 1959 from the Reds with Harvey Haddix and Don Hoak, gets past Philadelphia catcher Clay Dalrymple to tie the score at 4 in the ninth inning of a June 25 contest against the Phillies in 1963. Pittsburgh unfortunately would go on to lose the game 5-4 in 10 innings.

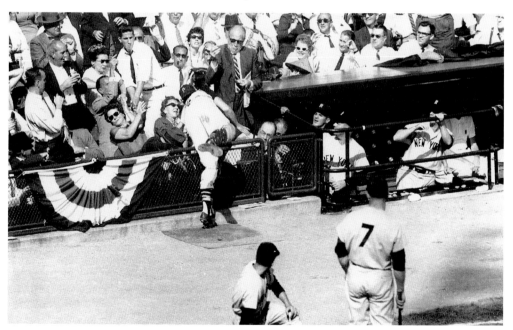

Known more as a fine hitter, Smoky Burgess makes an outstanding defensive play in the ninth inning of the seventh game of the 1960 World Series. The .295 career hitter, who was one of the greatest pinch hitters in major-league history, dives into the stands to make a spectacular grab of a Roger Maris pop-up to lead off the inning with No. 7, Mickey Mantle, watching on.

THE PITTSBURGH PIRATES

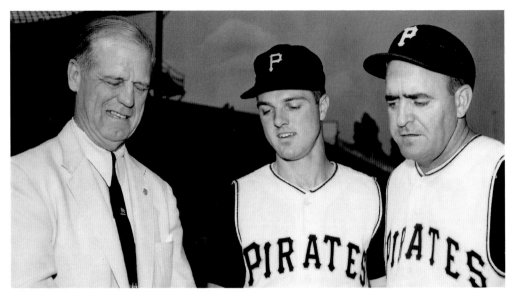

Lined up left to right is hall of famer George Sisler, a scout and special hitting instructor; infielder Dick "Ducky" Schofield, a .227 lifetime hitter; and manager Danny Murtaugh. While a poor hitter for most of his 19-year career, Schofield came up big in the clutch when it really counted. He hit .333 in 1960, holding down the fort after MVP Dick Groat broke his wrist in early September.

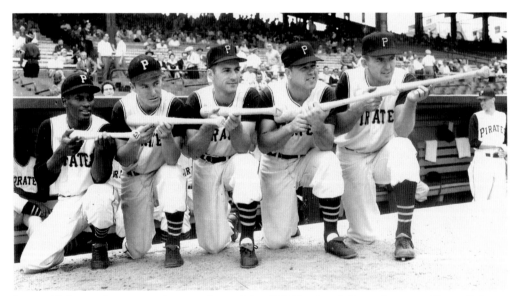

Pictured left to right are some key members of the 1960 Pittsburgh Pirates' potent offense. Roberto Clemente, .314 with 94 RBIs; Bill Mazeroski, who hit the historic series-winning homer; Dick Stuart, a team high 23 long balls; Gino Cimoli, who had an important pinch-hit single in the eighth inning of Game 7; and Hal Smith, who hit the second most important homer in team history (see page 84). This quintet led the 1960 World Champion Pittsburgh Pirates to an impressive offensive output that led the majors with a .276 average while topping the National League with 734 runs scored.

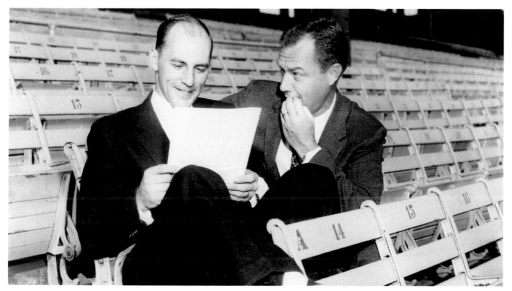

Looking over a contract are shortstop Dick Groat (left) and general manager Joe Brown. Whatever the Pirates paid Groat was worth the money as the five-time All-Star led the league in hitting in 1960 with a .325 average while capturing the league's MVP Award. Today Groat not only is part owner of Champion Lakes Golf Course in Ligonier, but does color on the radio broadcasts for University of Pittsburgh basketball.

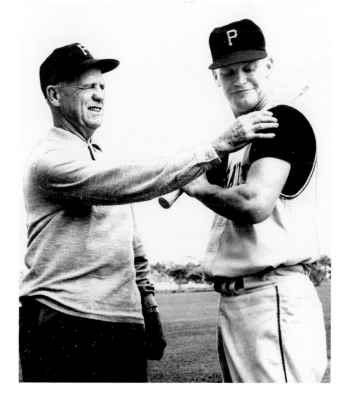

Being given a tip on hitting by the Bucs special hitting instructor George Sisler is third baseman Don Hoak. Hoak was a fiery leader who would do whatever he had to to win a game. A former boxer, Hoak hit .282 with 16 homers in 1960, finishing second in the MVP race. Hoak died of a heart attack in 1969 chasing a man who stole his brother-in-law's car.

A Rookie of the Year for the Cardinals in 1955, Bill Virdon got off to a bad start in 1956 and was traded to the Pirates. The Cardinals' impatience was the Pirates' gain. Virdon hit .334 the rest of the way and gave the Bucs a solid defensive center fielder. He stayed with the Pirates until his retirement in 1968, then coming back to manage the club in 1972 and 1973.

Coming over from the Reds in 1958, Harvey "the Kitten" Haddix was a stabilizing left-handed force in their rotation. Throwing the greatest game ever pitched in 1959 (please see page 82) Haddix had a very solid career. The winning pitcher in Game 7 of the 1960 World Series, Haddix won 33 games between 1959 and 1961.

A tremendous control pitcher, Vern "Deacon" Law went 20-9 in 1960 capturing the Cy Young Award for his effort. He sprained his ankle in the celebration after the Bucs clinched the National League pennant. He still had enough to pitch well in Game 7 of the series, yet called it his most disappointing moment in the majors when he was taken out in the sixth inning with Pittsburgh up 4-1. Following his marquee season, injury troubles crept up on Law, tearing his rotator cuff in 1961. An injury in 1963 sent Law to the voluntary retirement list. He bucked the odds and came back the following year. Miraculously, in 1965, he was one of the best pitchers in the league again, winning 17 games with a 2.15 ERA capturing the Comeback Player of the Year Award.

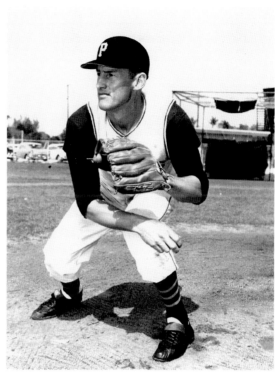

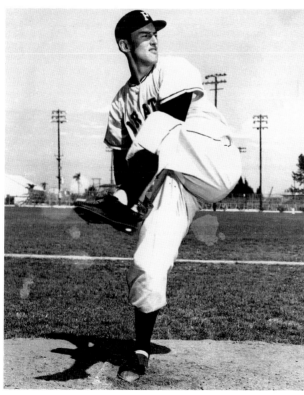

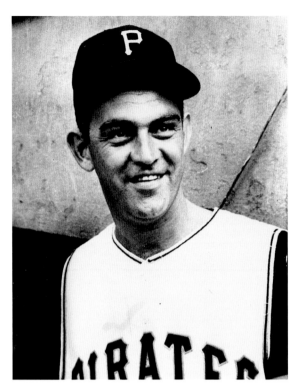

After a great career as one of the best relievers in the game with the classic championship Brooklyn Dodgers teams of the 1950s, Clem Labine was signed by the Pirates in August 1960 to help the bullpen down the stretch. Labine was well worth it going 3-0 with three saves and a 1.48 ERA for the Bucs the final two months of the season.

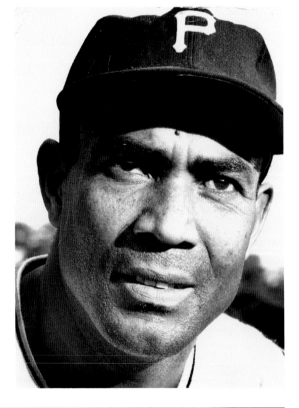

They say good things happen to those who wait. This saying was never more relevant than for pitcher Diomedes Olivo. He got his first opportunity to pitch in the majors for the Pirates in 1960. Two years later, in his official rookie season, he became perhaps the oldest rookie in major-league history at 43. He did not disappoint, going 5-1 with seven saves and a 2.77 ERA.

BACK ON TOP

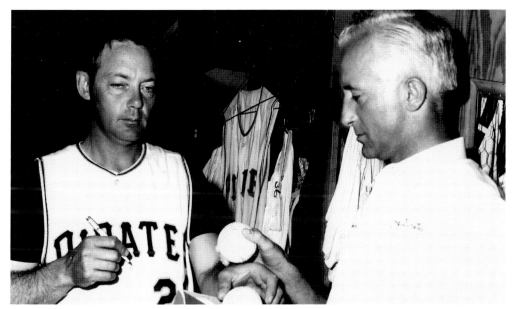

One of the best relievers in the 1950s, Roy Face continued to excel in the 1960s. Pictured here signing balls for fans, Face won the Sporting News Fireman of the Year Award in 1962 with a league-high 28 saves. After spending 15 seasons with the Bucs, Face was sold to the Tigers in August 1968. He retired the following year after a short stint with Montreal.

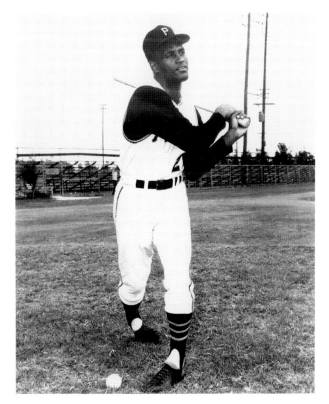

The 1960 season might have been a memorable campaign for most of the Pittsburgh Pirates, but for hall of famer Roberto Clemente, it represented a bitter season. Despite the fact he hit .314 with 94 RBIs for the world champions, Clemente finished only eighth in the MVP race. Angry at the slight, Clemente refused to wear his 1960 championship ring, choosing instead to don his 1961 All-Star Game ring.

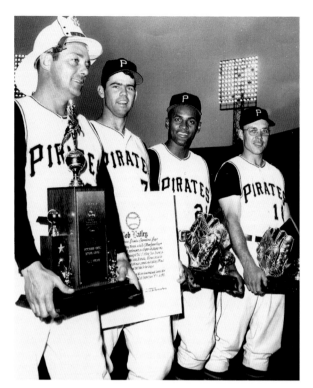

While most know 1960 was a banner year for the Pirates winning awards, 1962 was almost as impressive. Pictured from left to right are Roy Face, the Sporting News Fireman of the Year; Bob Bailey, the Sporting News Minor League Player of the Year; and Roberto Clemente and Bill Virdon, Gold Glove Award winners.

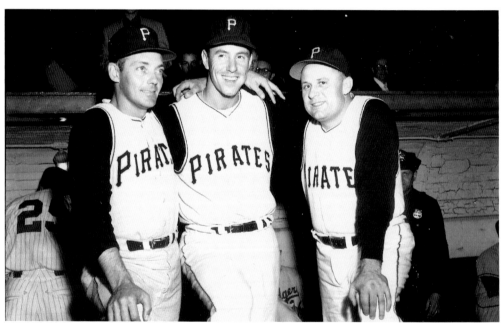

By the time these three Pirates greats retired, they each had etched their names in the baseball record books. Roy Face was the all-time National League leader in saves and games pitched by the time he retired, Bill Mazeroski holds the all-time mark for double plays by a second baseman for both a career and season, and Smoky Burgess was the major-league leader in pinch hits.

One of the best pitchers in the league, Bob Friend provided a very effective one-two punch with Vern Law during the championship season in 1960 with an 18-12 mark. A three-time All-Star where he earned three decisions going 2-1, Friend stuck with the Pirates until 1966 when he was sent to the Yankees. He retired the following season, three wins shy of 200 for his career.

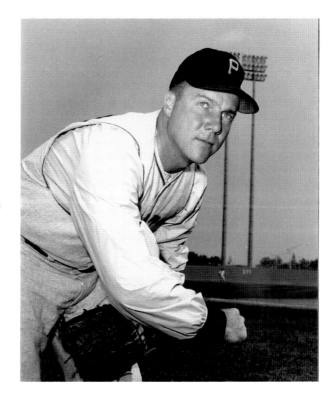

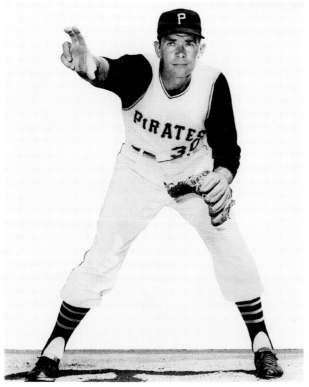

The only pitcher to throw a no-hitter in his first game for a team, Don Cardwell came to the Bucs in 1962 as part of the Dick Groat trade. Cardwell had a decent 1963 campaign before, and injuries all but negated his next season. He rebounded in 1965 with a 13-10 mark and 3.18 ERA. Cardwell eventually went to the Mets where he helped them win the Series in 1969.

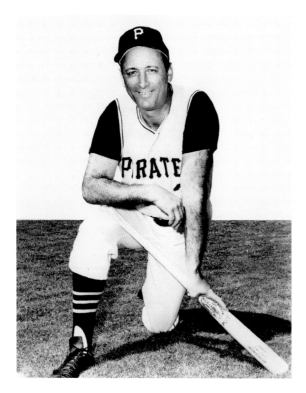

A supremely confident man, Harry Walker took over the reins of the club in 1965. After a 9-24 start his first year, Walker led the Bucs to a 90-72 record. A hitting guru, Walker helped many Pirates including Matty Alou and Donn Clendenon. Roberto Clemente said Walker was the first manager to treat him like a superstar. After he wore out his welcome, Walker's tenure ended two years later.

A seemingly minor trade in 1965 turned out to be very one-sided when Matty Alou came over from the Giants. Nothing more than an average slap hitter, Harry Walker worked with Alou, getting him to choke up on the bat and hit the ball to left field. The results were incredible as Alou won the 1966 batting title and finished his career with a .307 average.

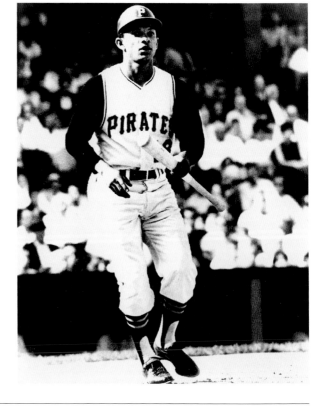

Perhaps Bill Mazeroski's most able defensive partner at shortstop, Gene Alley became an effective offensive force by his fourth season. Hitting .299 and .287 respectively in 1966 and 1967, Alley was an all-around player who won the Gold Glove those seasons while helping the Bucs set the major-league record for double plays in 1966.

A versatile athlete who was offered contracts from the Pirates, Harlem Globetrotters, and Cleveland Browns after graduating from Morehouse College, Donn Clendenon luckily chose baseball. Clendenon turned out to be a fine hitter, with double-digit homers for six consecutive seasons with the Bucs. Clendenon was lost in the expansion draft in 1969 and was traded to the Mets where he became the World Series MVP in 1969.

He could have been one of the best pitchers in the 1960s, throwing a no-hitter for the Angels in his rookie year in 1962, but Bo Belinsky had other plans, taking Hollywood by storm. Baseball performances were overshadowed by reports of who Belinsky was dating, a list that included Tina Louise (Ginger from *Gilligan's Island*). His baseball career came to an end soon after he came to Pittsburgh in 1969.

Fine-tuning his delivery in spring training is strikeout artist Bob Veale. Pittsburgh knew they had something special when Veale struck out 22 batters in a minor-league game in 1962. The Birmingham native kept it going in the majors by winning double digits for seven consecutive years while striking out over 200 on three occasions, including 276 in 1965, a mark that remains the team record today.

After 12 years of excellence, Roberto Clemente finally got the recognition he craved so badly when he was named the National League's MVP in 1966. That year the 12-time All-Star had career highs in both home runs, with 29, and RBIs, with 119. Clemente would keep the hall of fame–caliber performances going in 1967 when he captured his fourth National League batting crown.

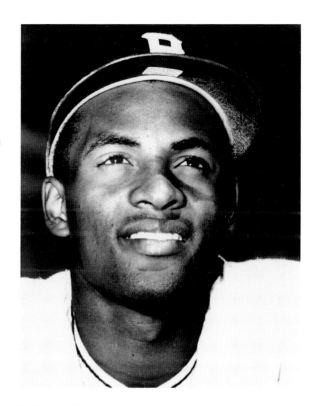

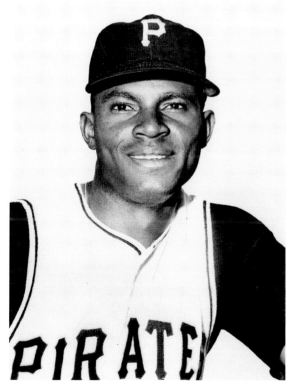

A great natural hitter, Manny Mota was oftentimes the odd man out in the Pittsburgh outfield but was still an important part of the Pirates offense in the 1960s. Taking advantage of Harry Walker's tutelage, Mota hit .332 in 1966, batting over .300 for seven of the next eight seasons. He finished his career in 1982 after a 20-year career as the all-time leader in pinch hits with 150.

THE PITTSBURGH PIRATES

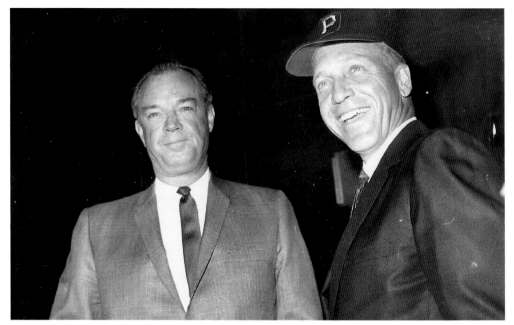

General manager Joe Brown (left) introduces new manager Larry Shepard in 1968. Shepard, who spent 18 years managing in the minor leagues and a year as the Phillies pitching coach in 1967, achieved his lifelong dream when he got the Pirates job. His dream would not last long. Shepard was not an effective communicator and made many strategic mistakes. He was replaced before the 1969 campaign was over.

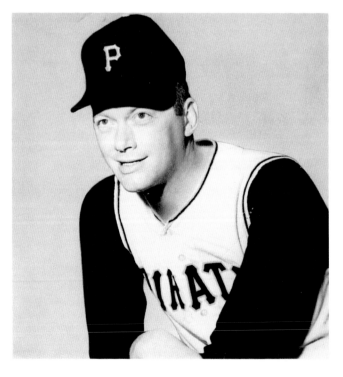

In an effort to put his club over the top, Joe Brown brought hall of famer Jim Bunning over from the Phillies in 1968. Coming off a very fine season, Bunning showed his best days were behind him, finishing 4-14 in 1968 and 14-23 in his two seasons in Pittsburgh before being dealt to the Dodgers. He retired in 1971, eventually becoming a U.S. congressman from Kentucky in 1986.

VICTORY AND TRAGEDY

1970 – 1979

Top five moments during the decade:

1. On December 31, 1972, Roberto Clemente was tragically killed when the plane carrying relief supplies to Nicaragua went down in the Atlantic Ocean. A few months later the hall of fame waved the five-year-after-retirement rule as Clemente, whose last major-league hit was his 3,000th only three months earlier, became the first Latin player ever enshrined in Cooperstown.
2. The Pirates won their first world championship in 11 years, defeating the Orioles in seven games in the 1971 World Series with Roberto Clemente leading the way with an MVP performance.
3. Willie "Pops" Stargell led the Fam-a-Lee to a dramatic seven-game come-from-behind World Series championship against the Orioles in 1979.
4. Rennie Stennett went seven for seven on September 16, 1975, tying the major-league record in a 22-0 win over the Cubs.
5. On September 1, 1971, the Pirates fielded the first all-black lineup in major-league history when Danny Murtaugh sent the historic group onto the field against the Phillies.

Team of the decade:

Willie Stargell (first base)
Rennie Stennett (second base)
Frank Tavaras (shortstop)
Richie Hebner (third base)
Richie Zisk (left field)
Al Oliver (center field)
Dave Parker (right field)
Manny Sanguillen (catcher)
John Candelaria (left-hander)
Dock Ellis (right-hander)
Dave Giusti (relief pitcher)

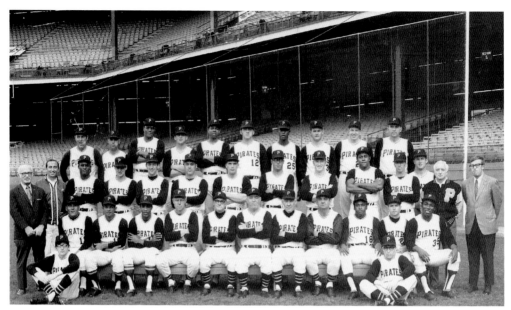

In the 1960s, there were few better minor-league systems than the Pittsburgh Pirates had. Pictured are the 1970 Pirates, which included several members of the 1968 Columbus Jets AAA team. Stars such as Fred Patek, Richie Hebner, Al Oliver, Manny Sanguillen, and Dock Ellis all came from that memorable minor-league team. While the 1970 Pirates may have closed out an era as the final team ever to play at historic Forbes Field, it also was a squad that began another championship run for the franchise. Pittsburgh played its last game at Forbes Field on June 28, sweeping the Cubs 3-2 and 4-1 on their way to capturing their first title since 1960, winning the National League Eastern Division crown.

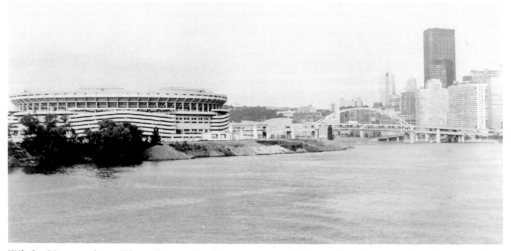

While 30 years later Three Rivers Stadium was mocked as a "cookie cutter" facility with no personality, when it opened on July 16, 1970, it was considered state of the art. Whether one liked Three Rivers or not, it housed many special moments for baseball fans in the Steel City as the Bucs won nine division titles and two world championships while playing there.

VICTORY AND TRAGEDY

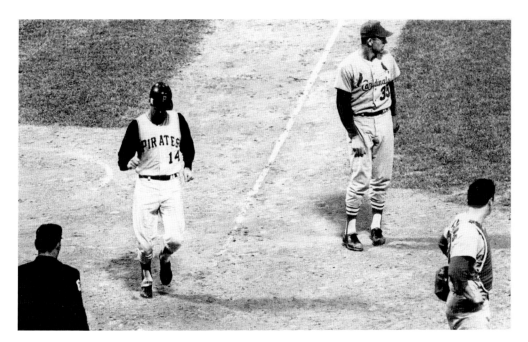

By the end of 1967, Gene Alley looked like he was going to be the next great infielder for the Pittsburgh Pirates. With two Gold Gloves and two All-Star Game appearances under his belt, the future looked rosy for the Virginia native. It was not to be. Pictured above scoring an 11th-inning run against the Cardinals in 1970, Alley was the victim of a shoulder injury in 1967 that hurt his defense. Knee problems afterward turned this once-budding superstar into a mediocre player. He did stick around until 1973, just enough time to earn a World Series ring in 1971.

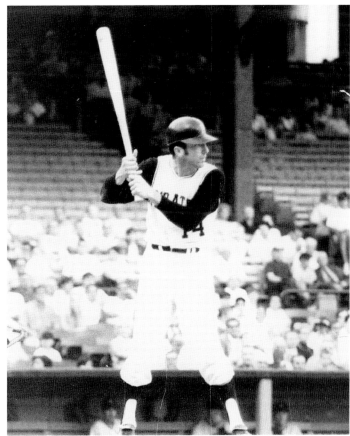

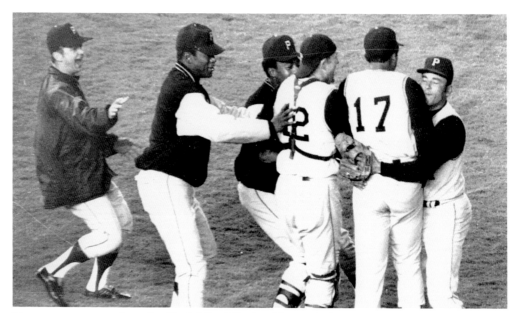

Pirates teammates mob pitcher Dock Ellis (17) after Ellis pitched a no-hitter against the Padres, 2-0, on June 12, 1970, in San Diego. Dock, who reportedly was under the influence of a hallucinogen when he tossed his gem, was unusually wild walking eight and hitting one batter. The no-hitter was part a fine 13-10 campaign for Ellis, one where he also finished seventh in the league in ERA with a 3.21 mark.

Taking over the starting shortstop job in 1969 was Freddie Patek. At five feet five inches, Patek was among the shortest major-leaguers in the game. He was not one of the greatest offensive threats, finishing with a .242 average, but he was an effective base stealer, swiping 385 career bases. Unfortunately Patek was dealt to Kansas City before the 1971 campaign where he became a three-time All-Star.

VICTORY AND TRAGEDY

After 18 years of running the franchise, John Galbreath turned over control of the club to his son Dan Galbreath in 1970. Dan ran the team through its second-greatest decade in franchise history, winning six National League Eastern Division championships and two World Series. He continued as president until the Galbreath family sold the team in 1985.

Joe Brown was simply the greatest general manager in Pirates history. He not only built one championship team in 1960, but he was one of the first to tap into the Latin markets and build a powerful farm system that helped make the club one of the best in the game during the entire 1970s. After 21 seasons doing a phenomenal job, Brown retired in 1976.

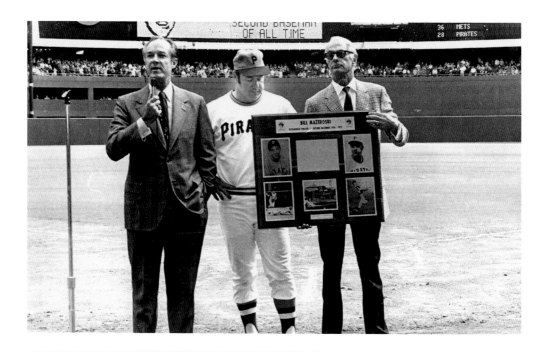

In the top photograph, Joe L. Brown (left) and Bob Prince (right), give a lifetime achievement award to Bill Mazeroski before he retires following the 1972 season. Many recognize him as the greatest defensive second baseman in history, and he has the statistics to back it up. The career National League leader in double plays turned with 1,706, Mazeroski also won eight Gold Glove Awards. All that is impressive, but what fans do not know is how good he was offensively. In the 1960s, no National League second baseman had more hits or home runs than Mazeroski, and this while playing in one of the least hitter-friendly parks in baseball in Forbes Field. While all this may have pointed to Mazeroski making the hall of fame, it took him three decades to get there, which he finally did in 2001.

VICTORY AND TRAGEDY

On September 30, 1972, Roberto Clemente doubled off the Mets' Jon Matlack. It would be a milestone hit, his 3,000th. It would also be his last regular-season hit. Three months later, Clemente was boarding a plane that had relief supplies for earthquake-ravaged Nicaragua. Soon after the plane took off, it went down in the Atlantic Ocean, killing all aboard, including the man who is still considered one of Pittsburgh's greatest heroes.

Bob Prince, who is playing around with Danny Murtaugh for the cameras during spring training in Florida, was one of the finest and most respected broadcasters in team history. Hired in 1948, Prince delighted and entertained Pirates fans with his unique sayings and stories. Inexplicably in 1975, "the Gunner" was fired amid heavy protests from the fans. Despite being ill, Prince returned to the booth in 1985. He sadly died a month later.

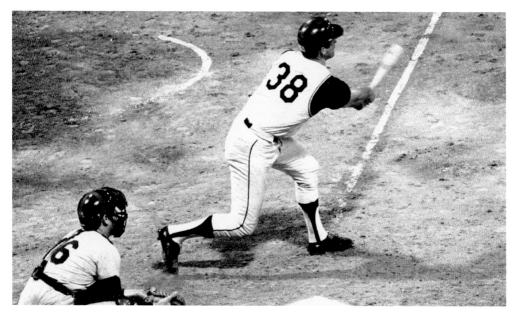

Bob Moose's (38) career was filled with highs and lows when he pitched for the Pirates. The Export native was on top of the world when he tossed a no-hitter in 1969 against the Mets. He was anything but three years later when he uncorked the wild pitch to lose Game 5 of the 1972 National League Championship Series (NLCS). Tragically, in 1976, Moose was killed in an automobile accident on his 29th birthday.

A grave digger from Boston who became a heartthrob to many female Pirates fans, Richie Hebner took over the starting spot at third base in 1969 when he led all National League rookies with a .301 average. Two years later, he was at his best in the 1971 NLCS against the Giants when he hit two homers including a clutch three-run shot in the fourth and final game.

A former fine-starting shortstop for the Giants in the early 1960s, Jose Pagan came over to the Bucs in 1965. With Gene Alley having a strong hold on the position, Pagan became an effective utility player hitting .289 in 1967. Pagan etched his name in Pirates lore when he had the game-winning double in the seventh and deciding game of the 1971 World Series.

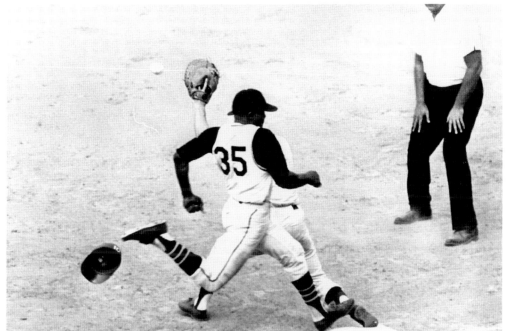

Many experts consider Johnny Bench the greatest catcher ever. For a short period of time in the early 1970s, there was one backstop who challenged their claim, Manny Sanguillen. Sangy was a fast, great defensive catcher who hit over .300 for three consecutive years. In 1971, the Panamanian was named to the Sporting News First Team All-Star squad, the only time in a nine-year period Bench was not selected.

THE PITTSBURGH PIRATES

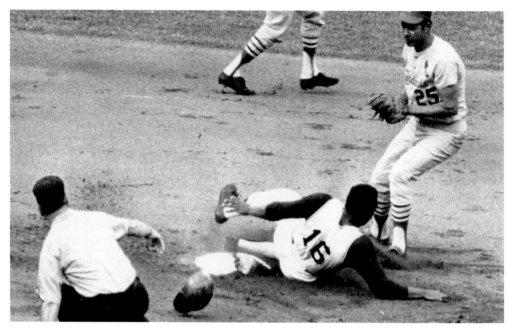

From his stellar performance his rookie season in 1969 where he was runner-up in the Rookie of the Year voting until he was traded in 1978, Al Oliver was a hitting machine for the Bucs. A brilliant line-drive hitter, Oliver eclipsed .300 for the first time in 1972, and stayed above .300 for 11 of the next 13 seasons. He retired in 1985 with 2,743 hits and a .303 average.

John Candelaria was a fire-throwing southpaw out of New York who let National League opponents know from the beginning he would be a tough pitcher to deal with. In his rookie year in 1975, he was at his best when he struck out a record 15 Reds in Game 3 of the NLCS. The following season Candelaria had another memorable performance tossing the first no-hitter in Pittsburgh since 1907.

The final piece to the puzzle in 1979 that helped the Bucs win the World Series was when general manager Harding Peterson brought Bill Madlock over from the Giants. Madlock, who had won two batting titles with the Cubs, had been disgruntled in San Francisco, hitting only .261 at the time of the trade. He hit .328 for the Bucs the rest of the way and topped that with an impressive .375 in the series.

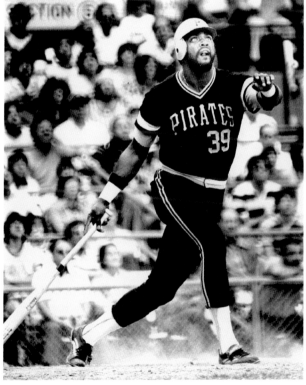

Dave Parker burst on to the scene in 1975, eventually becoming one of the best players in the game. Playing at his best despite a broken jaw, Parker won the 1978 National League MVP Award. While an offensive force, the three-time Gold Glove winner also had a cannon for an arm, which was on display in his MVP performance in the 1979 All-Star Game.

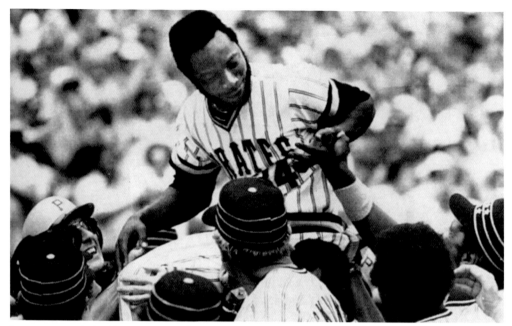

In a season of thrills in 1979, perhaps one of the biggest ones came off the bat of John "the Hammer" Milner. In the first game of a doubleheader against the Phillies on August 5, the Pirates fought back from an 8-3 deficit to tie the game going into the ninth. Loading the bases with two out, Milner hit a pinch-hit grand slam to give Pittsburgh a 12-8 win.

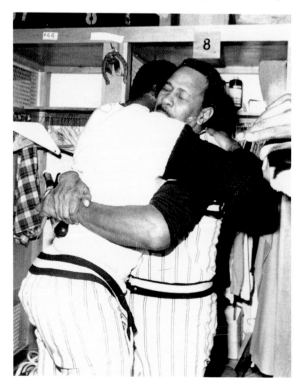

Two of Pittsburgh's biggest heroes in 1979 embrace after the Pirates swept the Cincinnati Reds to win the National League crown with a dominant 7-1 win at Three Rivers Stadium. Willie Stargell (right) hit .455 in the three games with two homers winning the NLCS MVP, while Dave "the Cobra" Parker (left) chipped in with a .333 mark.

Coming to Pittsburgh from Texas in 1978, Bert Blyleven gave the Pirates a solid addition to the starting rotation. Here Blyleven is doused with beer after he went the whole way in Game 3 of the NLCS, beating the Reds 7-1 to sweep the series. Complete games were not the norm for Blyleven in Pittsburgh as he often was at odds with Chuck Tanner for using his bullpen to close games.

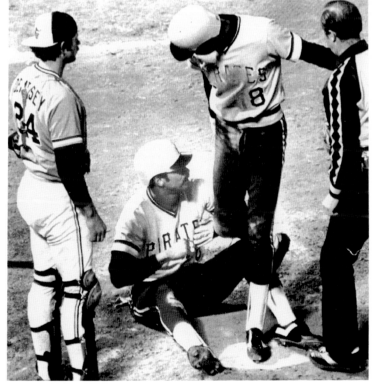

Down three games to one and looking like they would fall to Baltimore in the 1979 World Series, Pittsburgh fought back to send it to a seventh game. Here Bill Robinson sits on the ground after he was hit by a pitch with the bases loaded in the ninth inning of Game 7. Omar Moreno touches home plate to give the Bucs their final run in the 4-1 victory.

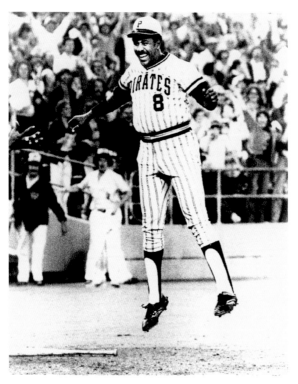

Willie "Pops" Stargell had one of the greatest decades a Pirate ever had in the 1970s. Twice he led the league in home runs, 1971 and 1973, while topping the National League in RBIs the latter season. Despite all his success, Stargell never won the league MVP Award. Knee problems and other injuries left his career in doubt as the decade was coming to a close, but he rebounded in 1978 by winning the Comeback Player of the Year Award; it would be a prelude to his most memorable season. Stargell hit 33 homers in 1979 and took the Pirates on his back, leading them to their fifth world championship. In the process Stargell won the elusive National League MVP as well as the MVP in both the NLCS and World Series.

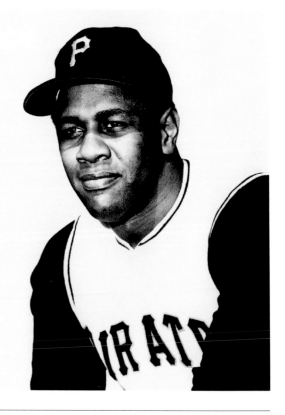

VICTORY AND TRAGEDY

FALL FROM GRACE

1980–1989

Top five moments during the decade:

1. A coalition led by Mayor Richard Caliguiri bought the Pirates from the Galbreath family in 1985 for $22 million. The Galbreaths had owned the club since 1946.
2. In 1988, Willie "Pops" Stargell was elected to the baseball hall of fame in his first year of eligibility.
3. Syd Thrift was named general manager of the club. Through several adept trades that included bringing Doug Drabek, Bobby Bonilla, Andy Van Slyke, and Mike Lavalliere to Pittsburgh, the club turned the corner, finishing a surprising second in 1988.
4. Bill Madlock won his second batting title, fourth overall, with the Pirates in 1983.
5. On June 4, 1986, Barry Bonds hit the first of what would be over 700 homers in a 12-3 win against the Braves.

Team of the decade:

Jason Thompson (first base)
Johnny Ray (second base)
Dale Berra (shortstop)
Bill Madlock (third base)
Barry Bonds (left field)
Andy Van Slyke (center field)
Dave Parker (right field)
Tony Pena (catcher)
John Candelaria (left-hander)
Rick Rhoden (right-hander)
Kent Tekulve (relief pitcher)

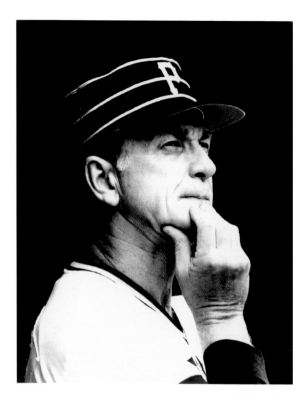

One of the few times in major-league history where a manager was traded to another team, the Pirates got more than they hoped for when they got Chuck Tanner from the A's in 1977. Winning a world championship in 1979 was the apex of his career. By 1985, things had turned much worse. After a 104-loss season, Tanner was relieved of his job.

One the best relievers in club history, Marietta College's Kent Tekulve is remembered not only for his unique submarine-style delivery but the way he shut down opponents when the game was on the line. Saving 158 games, second on the all-time team list, Tekulve set the all-time National League record for games pitched in 1986 with 842. He finished his career with 1,050.

The relationship that equipment manager John "Hoolie" Hallahan had with the Pirates lasted 50 years. As a visiting batboy in 1941, Hallahan eventually became the equipment manager of the team in 1957, a position he held for 34 years until his untimely death in 1991. The Pirates honored the memory of Hallahan by wearing the letter H in their sleeves that season.

After his breakout season in 1979, and setting the all-time Pirates stolen base record in 1980 with 96, Omar Moreno looked to have a bright future with the Pirates. Following a below-average 1982 campaign, Moreno signed with the Astros as a free agent. He never regained the form he showed in 1979, playing with four different teams before his career ended in 1986.

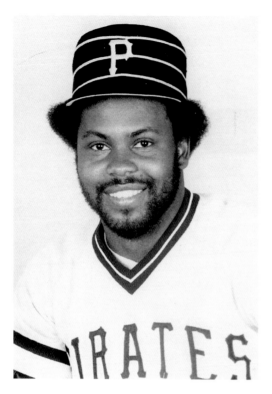

One of the best pure hitters in baseball during the 1970s and 1980s, Bill Madlock became the only player in major-league history to win two batting titles with two different teams. Madlock, who was also the only right-hander to win a batting title between 1971 and 1989, captured his first two crowns with the Cubs and his last two with Pittsburgh in 1981 and 1983.

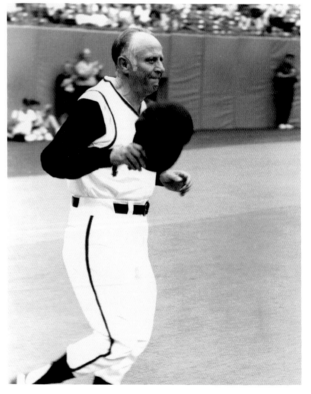

A pivotal member of the 1960 world champion Pittsburgh Pirates, Smoky Burgess sprinted on the field during an old-timer's game in the 1980s, tipping his hat to the cheering crowd. Burgess, one of the greatest pinch hitters ever, passed away in 1991 at the age of 64.

FALL FROM GRACE

The Pirates front office was looking for Canadian-born Doug Frobel to continue the line of excellence in right field that Dave Parker and Roberto Clemente portrayed before him. They unfortunately overestimated Frobel's talent. In five seasons, the Ottawa native could only muster up 20 home runs and a .201 average.

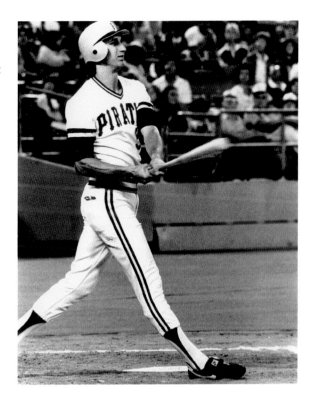

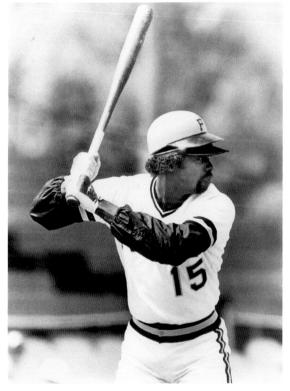

In one of the worst moves in general manager Harding Peterson's tenure, he sent John Tudor and Brian Harper to St. Louis in exchange for former All-Star George Hendrick. In half a season in 1985, he hit .230 with two home runs for the Pirates while oftentimes not giving anywhere near 100 percent. He was eventually dealt to the Angels in August.

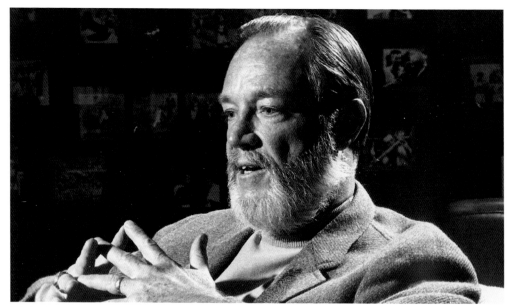

With the team in the midst in a 104-loss season in 1985, Pirates management called on an old friend to try to turn things around, general manager Joe Brown. Brown returned to his job in what was a short comeback. After clearing out some Pirates veterans for some young talent, Brown turned over the reins of the organization to Syd Thrift a few months later.

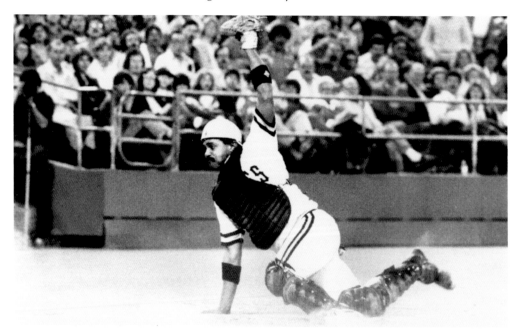

In a decade that was mostly forgettable when it came to the Pittsburgh Pirates, perhaps the best player to wear the black and gold was catcher Tony Pena. The Dominican, an all-around player who was a fan favorite for his hustling style of play, hit .286 in his seven years with the Bucs, while winning three Gold Glove Awards.

RISE AND FALL

1990 – 2006

Top five moments during the decade:

1. The Pirates captured their third consecutive National League Eastern Division championship in 1992. Pittsburgh lost in the NLCS for the third consecutive season, this time in a heartbreaking manner against the Braves, blowing a ninth-inning 2-0 lead in Game 7.
2. Barry Bonds won the 1990 MVP Award while Doug Drabek took the Cy Young Award as the Bucs captured their first Eastern Division championship in 11 seasons. It would be the first of two MVP Awards Bonds would win in a Pirates uniform, winning his second two years later.
3. On July 12, 1997, Francisco Cordova and Ricardo Rincon threw a combined 10-inning no-hitter against the Astros, winning 1-0 on Mark Smith's 10th-inning homer.
4. A group headed by Kevin McClatchy saved the Pirates by buying the financially strapped club for $85 million in 1995.
5. On April 9, 2001, the Pirates opened their magnificent new facility PNC Park. Considered one of the finest parks in the majors, PNC played host to the 2006 All-Star Game.

Team of the decade (1990–1999):

Kevin Young (first base)
Jose Lind (second base)
Jay Bell (shortstop)
Jeff King (third base)
Barry Bonds (left field)
Andy Van Slyke (center field)
Bobby Bonilla (right field)
Jason Kendall (catcher)
Zane Smith (left-hander)
Doug Drabek (right-hander)
Stan Belinda (relief pitcher)

Team of the decade (2000–2006):

Kevin Young (first base)
Jose Castillo (second base)
Jack Wilson (shortstop)
Aramis Ramirez (third base)
Brian Giles (left field)
Tike Redman (center field)
Craig Wilson (right field)
Jason Kendall (catcher)
Oliver Perez (left-hander)
Kris Benson (right-hander)
Mike Williams (relief pitcher)

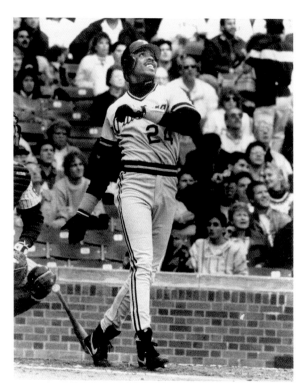

Steroid allegations aside, there are few players in baseball history that have had more impact on the game than Barry Bonds. Bonds got his start with the Pirates and led them to their last three Eastern Division championships. During his time in the Steel City, Bonds won two National League MVP Awards in 1990 and 1992.

In one of general manager Syd Thrift's most astute trades, he brought Texas native Doug Drabek from the Yankees in 1986. Drabek quickly became the staff ace, eventually becoming the second Pirate in history to win the Cy Young Award, which he did in 1990 on the strength of a 22-6 mark.

RISE AND FALL

It was thought that Pirates general manager Syd Thrift pulled the ultimate April Fools joke on the Pirates faithful on April 1, 1987, when he traded fan favorite Tony Pena to the St. Louis Cardinals for unheralded catcher Mike LaValliere (top), center fielder Andy Van Slyke (below), and pitcher Mike Dunne. It turned out that the joke was on the Cardinals. Pena never reached the lofty heights that he enjoyed in Pittsburgh while LaValliere became a two-time .300 hitter and won a Gold Glove. Van Slyke did even better, capturing five Gold Gloves as one of the best defensive center fielders in team history as well as the 1988 Sporting News National League Player of the Year.

There were few players on the Pirates in the 1980s and 1990s more respected by Pirates fans than Sid Bream, that is why it was ironic he broke their hearts in 1992. After signing with the Braves in 1991, Bream faced the Bucs in the 1992 NLCS. Bream, unfortunately for the Pirates, scored the winning run in the ninth inning of Game 7, sending Atlanta to the World Series.

A top prospect not living up to his potential with the Cleveland Indians, Jay Bell came to the Bucs in 1986 and eventually became one of the best shortstops in the game. Bell was a fine all-around player who had a phenomenal 1993 campaign, hitting .310 while earning a Gold Glove and Silver Slugger Award.

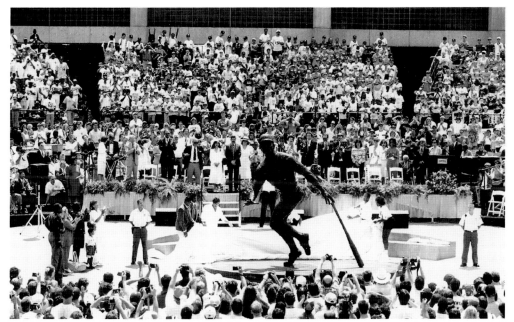

One of the most memorable ceremonies during the 1994 All-Star Game festivities was the dedication of a statue honoring the great Roberto Clemente. The statue was located at gate A of Three Rivers Stadium and was one of two statues at the stadium. Shortstop Honus Wagner, whose statue was built in 1955, was honored with the other one.

Pictured are arguably the two greatest catchers in franchise history, Jason Kendall (left) and Manny Sanguillen (right). Sangy, who starred for the Bucs in the 1970s, is giving an award to Kendall, a six-time .300 hitter in his nine-year Pirates career, commemorating his 1,000th game behind the plate.

Perhaps the best player to come out of the last half of the 1990s for the Pittsburgh Pirates was Brian Giles. Traded from the Cleveland Indians in a very one-sided deal, Giles instantly became a star, hitting over 30 homers for four straight seasons, while eclipsing 100 RBIs and the .300 plateau on three occasions.

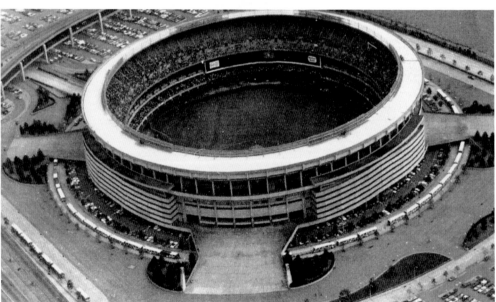

With the Pirates sinking into financial instability and in dire need of a new ballpark to revive this once-proud franchise, the powers that be came up with a controversial financial plan to build the much-needed facility. This meant that after 30 mostly successful seasons, Three Rivers Stadium would cease to exist. On February 11, Three Rivers was no more as it was imploded that day.

RISE AND FALL

The Pirates would play their last game at Three Rivers Stadium on October 1, 2000, losing to the Cubs 10-9. A very moving ceremony followed the game, and the gravely ill Willie Stargell threw the "last pitch" in the stadium before being shown a replica of a statue that was built and placed outside of PNC Park. Stargell would sadly die the day the new facility opened.

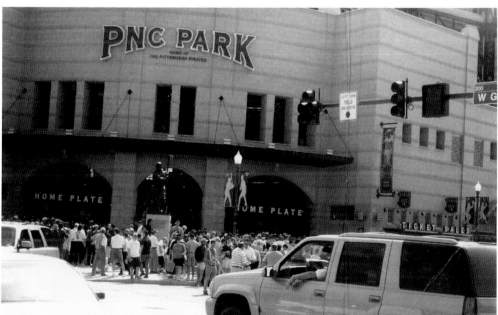

A large crowd gathers to enter the gates for the first game ever at the Bucs' new facility, PNC Park, on April 9, 2001. PNC Park is a magnificent facility that *USA Today* called "the best ballpark in America." While it has yet to field a competitive team in its short existence, a nucleus of good young players gives hope for the future for win-starved Pirates fans.

THE PITTSBURGH PIRATES

Discover Thousands of Local History Books
Featuring Millions of Vintage Images

Arcadia Publishing, the leading local history publisher in the United States, is committed to making history accessible and meaningful through publishing books that celebrate and preserve the heritage of America's people and places.

Find more books like this at
www.arcadiapublishing.com

Search for your hometown history, your old stomping grounds, and even your favorite sports team.

Consistent with our mission to preserve history on a local level, this book was printed in South Carolina on American-made paper and manufactured entirely in the United States. Products carrying the accredited Forest Stewardship Council (FSC) label are printed on 100 percent FSC-certified paper.

MADE IN THE USA